RIVERSIDE COMMUNITY COLLEGE
1916

...RT TECHNIQUES FOR **AMATEURS**

Art Techniques for Amateurs

Art Techniques
for Amateurs

Max Dimmack

A Studio Book

The Viking Press · New York

Published in 1970 by The Viking Press, Inc.
625 Madison Avenue, New York, NY 10022

Library of Congress catalog card number: 75-97777

Printed and bound in Hong Kong by Toppan Printing Co. (H.K.) Ltd.

Contents

The colour plates are between pages 56 and 57.

Acknowledgements

The author's thanks and acknowledgement are due to the following people for their generous assistance and willing co-operation in the preparation of this book; indeed, without such co-operation the task would never have been completed.

Students

The students of a number of high schools who allowed their work to be photographed, especially those of Newlands and LaTrobe (formerly Rosanna) High Schools, and also a number of students of the Coburg Teachers' College.

Teachers

A number of teachers in high schools, particularly Mrs Isabel Huntington, Mr S. Westbrook and Mr John Borrack, who kindly collected students' work for photographing.

Artists

The following artists who generously agreed to the reproduction of their work: John Borrack, Gordon Speary, A. W. Harding, Janice McBride, Kenneth Hood, Graeme Moore, and Clifford Last who not only made examples of his sculpture available but also his studio.

Photographer

Mr John Inglis for his patience, co-operation and skill in undertaking, over a prolonged period, the considerable task of completing all the photography, in both half-tone and colour.

Text Consultants

Mr John Borrack, Art Master, Newlands High School, and Mr R. Parker, Art Faculty, Burwood Teachers' College, for reading the manuscript and offering valuable suggestions which strengthened the text.

References

Art teachers develop the habit of collecting information, illustrations and teaching material from all kinds of cources. This material is collected over a period of years, during which the sources frequently are not noted or inadvertently become lost. To those artists, authors, publishers, and organizations, who may have furnished information in this way, some of which may have been incorporated in the present work, the author expresses his indebtedness and acknowledges the value of such assistance.

Introduction

You will find that this book is not concerned at all with picture construction or composition. Nor is it greatly concerned with elements and principles of design or aesthetics. These things, it was decided, are outside its purpose. Nor does it tell you much about what to draw or paint or construct, for you can decide that – you will know best what things and subject-matter interest you personally. But it is concerned with materials and tools and techniques, however, and with exercises and activities involving these. Above all, it is concerned with sound foundations which will enable you to plan and to create better art products – art products uniquely your own.

It is true to say that every kind of human activity subjected to serious study has its own basic approaches, specialized abilities and developed skills. The various subjects you have studied at school illustrate this. You know you can make little real progress in mathematics or language without some knowledge of their fundamentals. And art is no exception. When art is studied seriously, it soon becomes apparent that it has its own basic approaches, its own specialized abilities and its own latent skills that need to be developed.

This, at any rate, is the theme of this book. It emphasises consistently the importance in all art activities of basic things like seeing, establishing visual relationships, devising appropriate symbols, and understanding both the materials and the various ways of using them. It expresses the view that art is not accidental; it doesn't just happen. Art is made. It is made by all kinds of people, highly skilled and not so skilled, young and old, who all enjoy creating something of their own.

And art should be enjoyable. The act of creating, in itself, should be a pleasurable experience. And if the outcome of this creative act is successful, then it might even be exciting and tremendously satisfying. The little child at work in the kindergarten shows his pleasure and his satisfaction when his painting is finished; and Leonardo must have experienced the very same emotions, at the adult level, when finally he stood back to view the famous 'Mona Lisa'. But whether the drawing or the collage or the carving turns out to be good, or not so good, the making of it should have been an absorbing, enjoyable period of activity. If it hasn't been, then something somewhere, has gone wrong. At the same time, genuine progress in art involves much thought and work – sometimes hard work, sometimes prolonged work, sometimes frustrating work. But even when the work seems hard or frustrating, it should always be enjoyable and full of interest. That is why art is so fascinating as an activity. In fact, without a great deal of thought and hard work, art becomes a very limited business indeed. But you should enjoy your participation in art nevertheless. Your enthusiasm and delight should show in the way you work and in what you produce. In this way, you will discover that art can be wonderfully productive – and good fun. It's up to you to make it so!

There is no magic about art. Nor is it concerned necessarily with great artists, and famous masterpieces or inspired performances. More often than not, art concerns ordinary people –

you and me. We can all engage in art. We can all find an appropriate level at which to work. We can all find a suitable activity. We can all experience the personal thrill and excitement of creating something. Most of the necessary skills and attitudes in art are acquired; they are not born with us. We can all acquire them if we want to.

As well as skills, of course, art is concerned with materials — with pencils and paints and clay and chisels. But it is also concerned with what you perhaps should think of as invisible materials — and these unseen materials, in the final analysis, are far more important. Unfortunately you can't buy them; you can only develop them. This essential invisible equipment that you must have is made up of things like an attitude of mind, special ways of seeing, a capacity for understanding and interpreting what you see. The art works that you produce then become records of your heightened visual awareness of the world around you and your understanding of it.

But let us not regard the end-products as all-important, however. From some points of view, they might not be very important at all. For the processes of making art — the act of imagining, the act of interpreting, the act of creating, the experiment and the exploration, the solving of problems — these are more important then what is produced. The great value of art to the individual lies in the disciplined thinking, the disciplined vision, and the disciplined activity that it promotes.

Use the art activities described in the following pages to develop these things — and enjoy doing it!

Drawing with Pencil and Indian Ink

It is fitting that this book about art activities should commence with a chapter on Drawing, for every kind of artistic representation almost invariably starts from a jotting or a sketch; in other words, from a drawing.

Stated briefly, a drawing is simply a man-made arrangement of lines and marks which may convey meaning (1). At least one well-known contemporary artist, in fact, refers to his

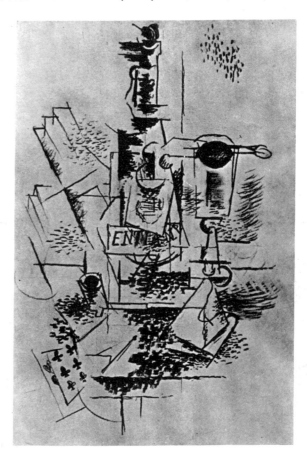

1 Drawing, crayon, by Georges Braque (1882–1964).

highly personal drawings as his 'marks'. Your ability to draw well or expressively depends essentially on your ability to visualize, to imagine, and to make the appropriate marks on a surface. And every other field of art activity depends on these same abilities. You will never

be able to paint pictures or make sculpture or produce prints successfully unless you can visualise and then express imaginatively in lines and marks what you have visualised. Every kind of artist makes drawings and, indeed, uses drawing as an indispensable and continuous part of his activity. Drawing, therefore, good drawing or draughtsmanship as we call it, is basic to every other form of artistic expression. You will soon realize that all the techniques and activities described in this book depend, to a greater or lesser degree, on developed drawing abilities. And like any other developed skill, the abilities involved in drawing require constant exercise and practice. The purpose of this chapter, then, will be to make you think about the nature of drawing and to indicate activities and materials you can use to practise these essential abilities. In this sense, you might regard Chapter One as basic to all the chapters which follow.

The Nature of a Drawing

A useful question you might ask, right at the beginning, is 'What is a drawing?' As drawings can vary tremendously in purpose, appearance, and in materials used, there is no simple or clear-cut answer, of course. But it might prove profitable to consider briefly some of the distinguishing features and general attributes of drawings; in this way you might come to a closer understanding of the nature of drawing.

First and foremost, a drawing is essentially *linear* (2); it consists of a system or arrangement of lines and marks. A painting, on the other hand, is not linear; it consists of areas or masses of colour, placed side by side or superimposed. Most of the lines in a drawing will probably be outlines which are observed and recorded by the artist, but which actually do not exist in nature. Strictly speaking, outlines are abstract representations of observed but non-existent boundaries between colour areas and surfaces of forms. A white cloud – a nebulous, vaporous mass seen against a cobalt blue sky – by its very nature has no fixed outline of its own, but if you want to draw that cloud, you have no alternative but to use an outline to distinguish between the white and the blue masses. So a drawing becomes, in fact, a linear representation of the boundaries between surfaces and forms. But a simple outline, on its own, generally conveys little precise information about the object represented – unless the artist is a superb draughtsman like Rembrandt or Picasso. So we elaborate our linear system (for example, by shading, or the use of multiple outlines) and employ colours to convey additional information. Even if the areas between the outlines are coloured in, so long as this linear quality is preserved, the representation remains a drawing. But when areas of paint take over and obliterate the linear arrangement, concealing the outlines, then the representation ceases to be a drawing and becomes, in fact, a painting. Needless to say, however, there is no precise boundary between drawing and painting, and you could argue the difference all day. It does not really matter.

Next, a drawing is essentially a *communication*. It conveys information. Both the artist drawing a girl's head (3) or the electrician making a wiring diagram will produce a drawing either to communicate information instantly or directly, or to record useful information for

2　Drawing, pencil. Student work.

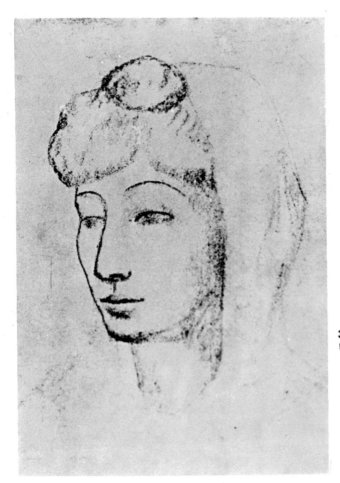

3 Drawing, charcoal, *'Head of a Woman'* (1905), by Picasso (b. 1881).

subsequent communication. All the artists in history have used their drawing abilities as means of communication. And the more the artist understands the use of line and its communicative potential, the more successful as a communication his drawing is likely to be. Later on in this chapter, you will be encouraged to try to communicate information and to differentiate between objects just by using varied line treatments and effects.

A drawing is essentially an *abstraction of an experience.* Any drawing done consciously must stem from an experience of some kind. This experience might be quite simple or it might be quite involved. If you draw a tree, for instance, the experience might be as simple as merely observing the tree or walking past it. On the other hand, Rembrandt made many drawings of his wife (4), and obviously the relationships and experience involved in this case would be very personal, involved and varied. The drawings people make, therefore, tell us something about their experiences and the events in which they participate.

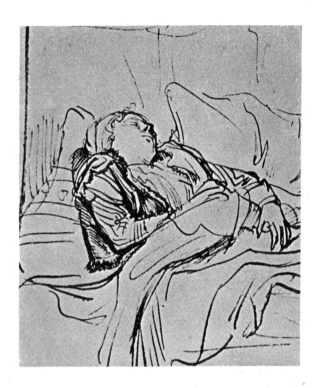

4 Drawing, pen and ink, (detail), *'Saskia Asleep in Bed,'* by Rembrandt (1606–1669).

A drawing, again, is essentially *graphic*, and as writing historically evolved from drawing, a very close relationship exists between drawing and writing. Drawing, in a sense, is 'written'. Both writing and drawing depend on the principle of the abstracting line; both, in essence, are abstractions. Even the materials generally used are common – pencil, pen and ink, brush, and so on. When we look at the great art of China, we see this close relationship. In China, no real distinction has ever been made between drawing and writing (5). A study of Chinese drawing and calligraphy will show this clearly.

A drawing is essentially an *abbreviated representation* of the subject-matter, like a summary of a paragraph or a precis (6). A good drawing generally omits non-essential, extraneous, incidental, or superfluous details. It represents fundamentals, distilling the utmost from the subject. A pen drawing by Picasso or Matisse condenses a human figure into a few swift, expressive pen-strokes – lines, however, rich in meaning and artistic merit.

Finally, it is possible to communicate information about, or to represent, almost every conceivable material or surface (33) by using appropriate arrangements of lines and marks. So, when you are drawing, you can invent or adapt line treatments to describe stone, cloth, wood or water; to convey information about rough or smooth, soft or hard, heavy or light; or even to convey feelings such as angry or calm, tired or lively, happy or unhappy.

So, as you can see, when you have learned to use line expressively, you have always at your disposal a remarkably efficient, useful and personal means of communication.

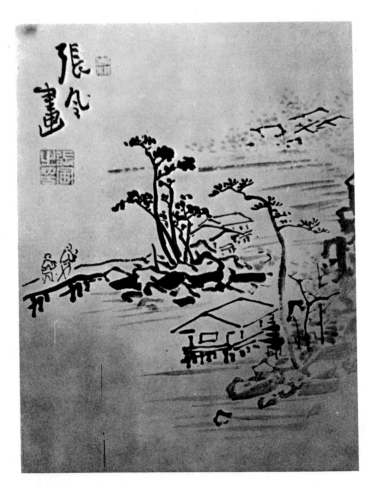

5 Drawing, brush and ink on rice paper, *'Landscape,'* by Chang Feng. (active c. 1650)

The Function of a Drawing

In general, drawings are made to serve three main functions or purposes.

Probably the most common role of drawing is to record needed information, as an artist does in his sketch books (6), or to show essential details, information or factual knowledge, as in a biology drawing, a production graph or in the diagrammatic representation of some experiment in science or chemistry that you see in text books. For the artist, however, drawing not only disciplines his eye and hand to instantaneous co-ordinated activity, but through constant observation and sketching, it enables him to build up a mental encyclopaedia of information about forms, shapes, colours and textures which he can recall as he needs to. In this way the artist extends and enriches his artistic vocabulary.

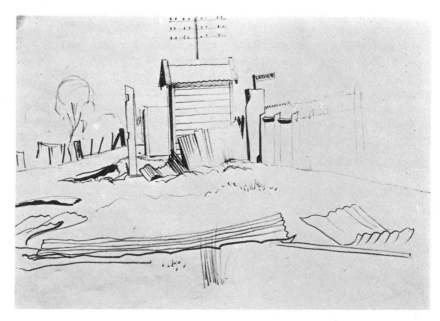

6　Drawing, pencil, made at the scene by the author.

7　Painting, oil *'Guernica,'* (1937) by Picasso.

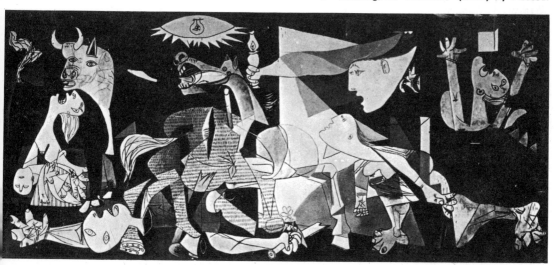

Again, drawings are made as the initial, clarifying, preparatory stage (or stages) in the evolution of a subsequent painting, or piece of sculpture, architecture, or applied design of any kind. Imagine an architect designing a modern home or a fashion designer creating an evening gown without making preliminary sketches and working drawings! For his famous painting 'Guernica' (7) Picasso prepared some 70 or 80 working drawings (8, 9, 10) in which he clarified ways of representing his subject-matter and details of the composition.

Finally, in the fine arts, a drawing can be made as a complete and final expression in itself, existing in its own right and with a validity of its own (11). Thus drawing constitutes a legitimate art form with its own characteristics and delights.

Qualities of Good Drawing

How can you recognize a good drawing? What qualities or attributes do you look for? Again, there is no simple, correct answer. But among the qualities a successful drawing might display – and which you can learn to detect and to enjoy – are evidence of the artist's

8 Drawing, *'Woman and Dead Child'* (1937)–drawing by Picasso.

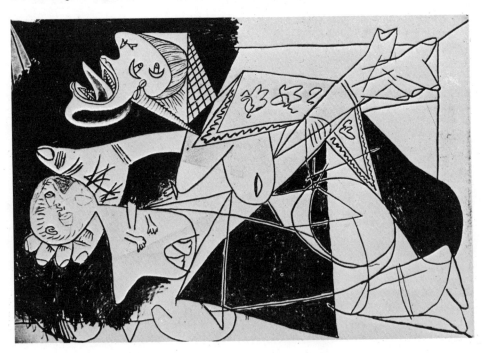

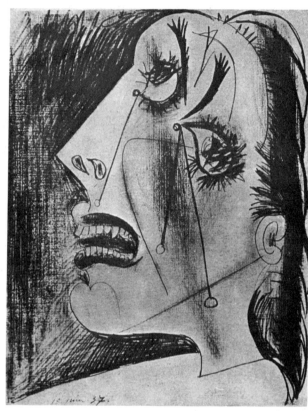

9 Drawing,*'Weeping Woman'* (1937)—drawing by Picasso.

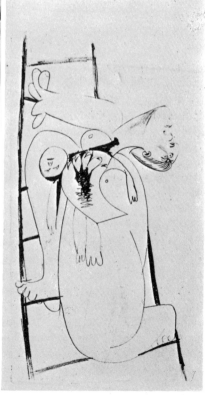

10 Drawing, *'Woman with Dead Child on Ladder'* (1937)—drawing by Picasso.

8,9,10, Drawings by Picasso associated with the production of his *'Guernica'* painting.

11 Drawing, ink, *'Communications West'*
(1963) by Max Dimmack. In the possession
of Burwood Teachers' College.

competence and technical ease with his materials, his decisive approach to the interpretation
of his subject, variety in the line effects he employs, directness of communication, economy
of expression, definition of subject-matter, and certainly vision and imagination. If you can
observe all or most of these attributes in a drawing, then it is likely that you are looking at a
good drawing. But remember that accuracy in recording or representing actual physical
appearances is only one of the qualities to be considered, and there will be many occasions
when this quality is unimportant. At times, the artist's personal symbolic interpretation is of
much greater significance. Picasso can draw 'realistically' when he wants to, but the wonder-
fully evocative preparatory drawings he made for his 'Guernica' are little concerned with
actual physical appearances nor are they imitative in intention (8, 9, 10). But they are
remarkably successful examples of graphic communication. They are, in fact, good drawings.

The Importance of Seeing

Looking implies merely turning one's vision upon an object. But to see implies to penetrate,
to perceive, to analyse, to detect relationships, to understand. How often, when you have
understood a problem, have you commented, 'I see'. This difference between merely looking
and efficiently seeing — and understanding — is vital to the practice of art, and to drawing
especially. Most of the qualities of good drawing which we have already mentioned are the
direct outcome of disciplined vision and directed observation.

Therefore, to become proficient at drawing — or any kind of art — you must learn to control
and direct your vision. You must, in fact, learn new ways of seeing. All of us tend to see what

we have been taught or conditioned to see, and how and what we see is learned as a result of our total experience. But while all people – except the blind – can look, all do not automatically see, and most certainly all people do not see alike. A significant difference between the artist and his fellow-man is that the artist has developed his visual efficiency; he has learned to see in new ways. He has trained his vision to see through and beyond superficial appearances, to penetrate and to analyse the basic structures and relationships through which he can understand, interpret and then represent his subject-matter. Just as a good cook not only sees the icing but also understands something of the nature of the cake under the icing, so the artist sees both the superficial appearances and observable details as well as the fundamental nature and the internal relationships of his subject-matter. An arm bent is much more than a creased sleeve. It is, in fact, two cylinders, one vertical, one horizontal, meeting at a point of juncture and creating, as a result, many subtle relationships of form, proportion, length, direction, contour, even foreshortening. Until you can see an arm in this way, and analyse what you see, you will never be able to draw an arm competently and convincingly. But it can be done. Artists have learned to do this. And you can learn to do so, too.

Three important words are now introduced into our discussion of drawing to help you see, and then to use, visual relationships in the subject-matter of your drawing. If you can detect these basic visual relationships and accurately transpose them as lines and marks on your paper, you are well on the way to producing a soundly-structured, coherent and convincing drawing. The three words are:

> parallels continuations affinities

When you have learned the significance of these words in an art context, and trained your vision to see them, you have made real progress in this business of drawing and creating art.

As in writing a book, one of the hardest aspects of making a drawing is to get started, to find a starting point that offers possibilities for further action. Most subject-matter contains either concealed or visible systems of parallel lines, or *parallels* (13). These can be straight or curved, immediately opposite or somewhat removed. But learn to see them. Use them in the initial blocking-in stage to get you started, to help plot your basic structure. The inside and outside edges or contours of a sleeve probably will be seen initially as parallel lines; two bottles in a still-life form a set of vertical parallel directions; often parallel curves or directions can be detected in rocks or trees and the hills behind them. You can find these parallels in all kinds of subject-matter. Use them to give a sound basis to your drawing. *Continuations* (14) are seen when you visually follow lines through to their ultimate destinations. A line must go, say, from point A to point B, but where would it lead to if it continued beyond point B ? Follow it through visually; more often than not it will continue into another important structural line. If you are drawing a man from the front, you might find that the inside edge of a sleeve, if continued, would lead directly into the outside edge of a trouser leg. If it does, a relationship is established. Analyse the nature of this visual relationship, and then use it to further strengthen your drawing. Find similar continuations, and use them, too. The word

'affinity' means structural resemblance or similarity of character. If you analyse the subject-matter of your drawing, you will be able to find lines which are neither parallels nor continuations, but which nevertheless show affinity and relate in some way, one to the other. We can call these lines *affinities* (15). Again, if you can detect this relationship and represent it accurately in your drawing, you are extracting essential structural lines from the subject-matter. Let's say you are drawing a man again, a man in an unbuttoned rain-coat. Look at the outline or edge of his shoulders on each side of his neck; you will probably see two lines of approximately the same length, direction, and angle, only reversed or opposed. They are related lines. Look at the two inside edges of his unbuttoned coat. The two long lines that you

12 Painting, oil and enamel, *'Hot-Shed'* (1953), by Max Dimmack.
In the possession of the artist.

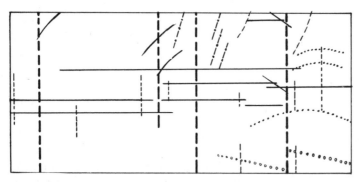

13 Parallels. Diagram based on the painting above showing the use of systems of parallel lines, identified in the subject, to give a structured basis to the composition.

14 Continuations. Diagram showing the continuation of lines and directions so that they are re-established, thus creating linear relationships and structural unity.

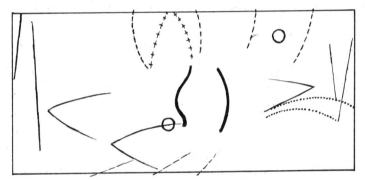

15 Affinities. Diagram showing the use of lines which are neither parallels nor continuations, but which show an affininity of direction, shape, curve, etc.

see are neither parallels nor continuations but nevertheless they are similar, though reversed; they form linear affinities. Train yourself to see relationships such as these. This capacity to see, to understand and to use parallels, continuations and affinities will lead to remarkable progress not only in your drawing but in your other art activities as well.

Paper

Drawings normally are made on some surface, and the traditional and common surface is paper. The nature and purpose of the drawing largely determines the sort of paper. The activity of drawing can be carried out successfully on almost any kind of paper and, indeed, you should experiment with as many kinds and sizes of paper as you can obtain. For quick sketching, working drawings, preliminary studies, practice exercises and the like, inexpensive papers such as detail paper, bulky newsprint, litho paper, shelf paper and similar papers are

quite satisfactory. The fact that they are cheap and expendable is an advantage; it encourages you to draw with greater freedom and adventure, to experiment more. For more considered or finished drawings, better quality papers such as cartridge paper, smooth watercolour paper, even some of the good quality cards and thin paste boards, are needed. Avoid working all the time on paper of the same size; this limits your opportunities to explore fully the feeling for scale in your drawing. Using a variety of sizes, large and small, gives you the freedom to increase or diminish the effect of scale as the subject-matter warrants. It also enables you to experience the full range of drawing techniques and the graphic potential of the various media. Dry drawing materials can be used on practically any sort of paper, but wet materials such as pen or brush and ink need a non-absorbent surface like cartridge paper or surface board. For best results, you need a firm surface under your paper, and a drawing board is essential. To prevent the grain of the board, or indentations or other damage, from registering, always place a backing sheet or two under your drawing paper. This simple precaution might save you frustration or a major disappointment some day.

Media

Drawings in black and white can be made in a wide variety of media or combinations of media. Theoretically, any material or tool which can be used to make a mark either by itself or as a result of dipping in ink or paint can be used. In practice, however, materials for drawing should provide a direct means of self-expression, should be predictable and manageable in behaviour, should be flexible and responsive, and through expressive line treatments should permit an infinite range of linear and textural effects and drawn detail.

Many of the media (16, 17) available for drawing indicate readily the nature of the end-products resulting from their use. Thus, you can make drawings, using a simple direct approach, in soft black pencils (18) (grades B to 6B, kindergarten pencils, carpenters pencils), in black crayons (such as conte crayon (19), wax crayon), in charcoal (3) (purchased or home-made), black pastel (oil or dry), pen and ink (Indian ink preferably (20), but ordinary writing ink if nothing better is available), pen and ink and wash (22) (see p. 65 for explanation of wash), charcoal over ink and wash, pencil and pen and ink, brush and ink (23), any similar combination of media, black ball-point pen (25), black felt-tipped markers (26), water-based fibre-tipped marking pens (such as Pen-touch), black liquid shoe cleaner, or in black paint (either water-based or diluted oil colour). You can also produce drawings of a more complex nature by employing one of the resist techniques (such as scratched or 'sgraffito' drawings incised in a black surface applied over a white crayon base), or by using purchased scraperboard, but these specially prepared boards are usually expensive.

While the traditional drawing materials are the pencil and the pen, all kinds of improvised materials (27) can be used to advantage so long as they will transport ink from the bottle to the paper. You can obtain a surprising variety of graphic effects with such tools as dry twigs, small feathers, pieces of grass, pieces of stiff string, rolled paper, cardboard strips used on edge, split cane, pieces of sponge or foam rubber, and so on, which you can press, drag,

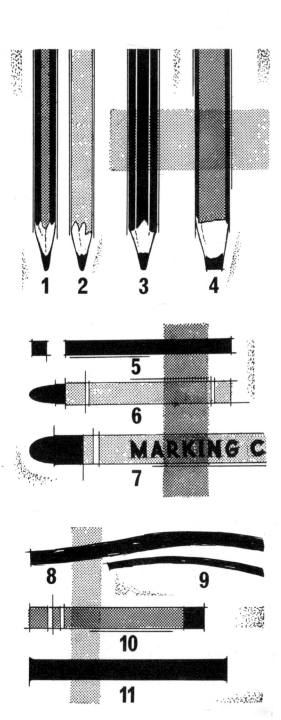

16 Common drawing materials (dry). 1,2–soft black pencils; 3–kindergarten pencil; 4–carpenter's pencil; 5–conte crayon; 6–wax crayon; 7–marking crayon; 8–charcoal, thick stick; 9–charcoal, thin stick; 10–oil pastel; 11–traditional pastel.

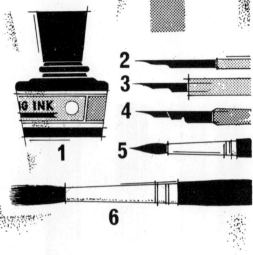

17 Drawing materials (wet). 1–Indian Ink; 2–mapping pen; 3 –drawing pen; 4–drawing pen; 5–sable brush; 6–bristle brush for stippling, dry brush work, etc., 7–ball-point pen; 8–fibre-tipped pen; 9–fibre-tipped marker; 10–felt-tipped marker; 11, 10–liquid shoe dye and foam applicators.

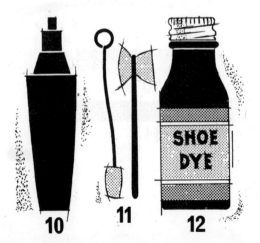

18 Drawing, pencil. Student work.

rotate, stroke, or jab, to make contact with the paper. It is quite legitimate to use such aids. Build up a collection of your own. Experiment to find out what your improvised tools can do and the special effects they can obtain (28, 29). Try diluting the ink with clean water; experiment with tones and gradations from solid black to the most delicate grey. Try, at times, working on wet or damp paper (30); let the pen lines 'bleed' and drops of ink flow or run as you tilt your board. Experiment also with the new types of pens coming on the market, pens which use fluids other than inks. Many of these possess distinct possibilities for drawing and may contribute significantly to an expanding range of drawing media.

Charcoal (3) is a useful medium for quick sketching and for exercises in rapid working methods. It is used directly on large sheets of paper such as detail paper or litho paper in a manner similar to pastel. Variations in pressure produce corresponding variations in line and tone, ranging from soft grey to black in a variety of widths. Masses of charcoal can be blended, and edges softened simply by rubbing with a finger. Experiment to find out the possibilities,

19 Drawing, conte crayon. Student work.

20 Drawing, pen and ink. Student work.

21 Drawing, pen and ink and wash. Student work.

22 Drawing, pen and ink and wash. Student work.

23 Drawing, brush and ink (detail),
by the author.

24 Drawing, brush and ink,
figure studies. Student work.

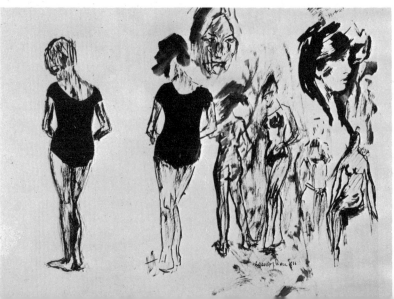

25 Drawing, ball-point pen.
Student work.

26 Drawing, felt-tipped marker.
Student work.

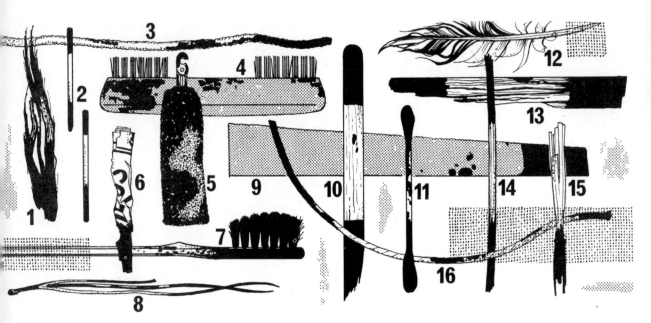

27 Drawing materials (Improvised). From the left, this illustration shows the following impro-
vised materials which have been used to make marks in ink on paper——1—stringy bark; 2—dead
matches; 3—pipe cleaner; 4—wire shoe brush; 5—foam centre-piece from hair curler; 6—rolled
paper stump; 7—old tooth brush; 8—pine needles; 9—cardboard strip; 10— icy pole stick;
11— cotton wool bud; 12—feather; 13—broken stick; 14—piece of cane; 15—piece of straw;
16— length of stiff string.

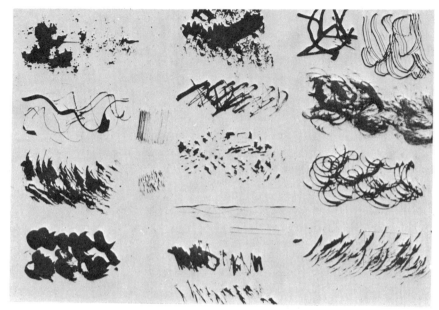

28 Experimental exercise, improvised materials and ink. Student work.

29 Experimental exercise, improvised materials and ink. Student work.

30 Experimental effects, ink on wet paper. Student work.

and limitations, of charcoal as a drawing material. Because it is a very soft medium prone to smudging, any completed charcoal drawings which you want to keep in good condition should be sprayed immediately with a fixative (42).

If you want to, you can make your own charcoal sticks quite easily. Tightly pack willow sticks, stripped of bark and of even length, in a tin such as a baking powder tin or a mustard tin, and perforate both ends of the tin. Now place the closed tin containing the sticks in a fire or oven, or even in an incinerator, where they burn slowly out of contact with the air until they are completely carbonised, thus becoming charcoal sticks. Use willow because it is soft and free of resin or gum, and the resultant charcoal gives a very even tone.

Useful Exercises

Progress in drawing comes as a result of directed observation, of seeing, thinking, and continuous practice with the media. Practise this approach every opportunity you get. Even when you are engaged on other art activities such as painting or print-making, don't neglect your drawing. Drawing is basic to all fields of art. Don't forget it. Make or buy cheap sketch pads or note books and draw whenever you have time. Almost anything and everything can provide subject-matter for drawing experiences.

Exploratory exercises

Every now and then, engage in 'freeing' exploratory exercises using different drawing media – this time a pencil, next time Indian ink and improvised tools, then conte crayon, and so on. Explore the widest range and greatest number of different effects you can obtain from a single material. Have you ever explored fully the communicative potential of the humble pencil? A surprising range of linear, tonal, and textural effects can be achieved by variations in the kind of impact, in the angle of the stroke, in pressure applied, even in the way the pencil is sharpened, using only the one pencil (31) Many of my students repeatedly have obtained 30, 40, and even more, separate identifiable effects from an ordinary pencil. Try this exercise; see how many effects you can get!

31 Exploratory exercise, pencil. Student work.

Exercises in differentiation and communication

Now try exercises in differentiation and communication. Take a single material – pencil, again, if you like. Use it expressively to convey clear visual distinctions between pairs of lines (32), such as soft line, hard line; heavy line, light line; angry line, calm line; smooth line, rough line; lively line, tired line; and so on. Then move on to textures (33). In little panels, say $1\frac{1}{2}$ inches square, using the same pencil, suggest the different textural qualities of a gravel path, a trimmed lawn, a paling fence, the bark of a tree, a tiled roof, the surface of still water, foliage of different trees, and similar examples. Don't draw the actual objects; this is essentially an exercise in suggesting graphically common textural effects. Now combine these two exercises in line and texture by drawing objects (34). Use your pencil to

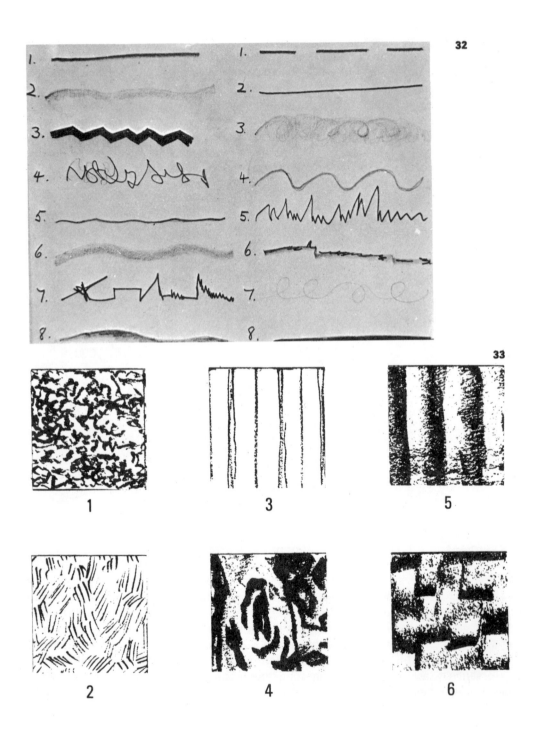

32 Pencil differentiations, *types of lines*. Student work.

33 Pencil differentiations, *textures*. Student work. 1—gravel surface; 2—grass; 3—paling fence; 4—bark of tree; 5—corrugated iron; 6—tiled roof.

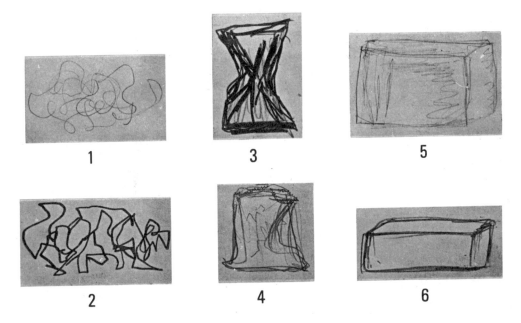

34 Pencil differentiations, *objects*. Student work. 1—tangled string; 2—tangled wire; 3—crumpled petrol tin; 4—crumpled paper bag; 5—block of ice; 6—block of concrete.

differentiate between, and to communicate information about, pairs of objects, such as a block of ice, a block of concrete; tangled wire, tangled wool or string; a crumpled tin, a crumpled paper bag; a folded newspaper, a folded linen serviette; a silk ribbon, a strip of tin. If you can convey pictorially and visually the essential differences between these pairs of objects you are using your pencil expressively and utilizing its range of possibilities. Exercises like these, which you can easily devise yourself, are challenging, occupy only a few minutes, and when practised regularly cannot fail to strengthen your capacity to visualize and to reproduce in appropriate form what you visualize.

Exercises in definition

Try also exercises in definition. Again, take a single material – pencil, or brush and ink, for example. Using all the possibilities of your selected material, make a series of drawings of trees (willow, poplar, pine, and elm, for instance) so that each tree is clearly defined (78). Visualise each tree in its characteristic appearance and growth pattern. Draw them so that there can be no confusion. Now study your drawings. If, for example, your willow tree looks like a feather duster or some kind of tree-fern, you have either visualised inadequately or you have been unable to express what you have visualised. In both cases, you need more practice. Now, in pencil, draw some typical tree of your choice. Look at your drawing critically. What details or attributes of that tree have you overlooked and omitted? List them. Look at drawings and paintings of similar trees by artists whose work you admire. Your second drawing should show an improvement in definition – it should be a more clearly visualised, more convincing, more communicative drawing of a tree. Try similar exercises in definition with other subject-matter.

Exercises in improvisation

Exercises in improvisation provide opportunities for experiment and widen your artistic horizons. Work in assorted materials, purchased and improvised, separately or in combination. Take an actual painting, reproduction (35), or even a photograph of, say, a landscape. Re-draw it, changing its appearance, altering its composition, and developing a new centre of interest; try different effects, experiment with different textures – in other words, use your drawing materials to produce an improvisation on a given theme (36, 37).

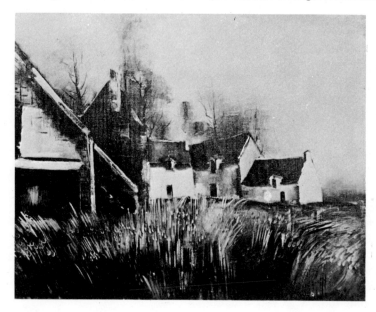

35 Painting, oil, *'French Farmhouses,—Summer'*, by Vlaminck (1876-1958)

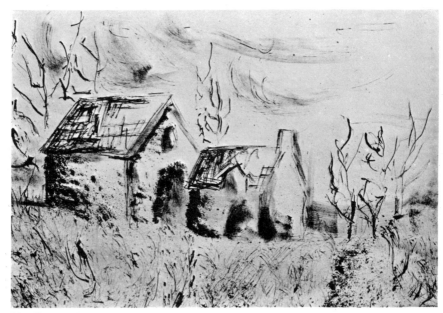

36 Exercise in improvisation, ink, based on the Vlaminck reproduction. Student work.

37 Exercise in improvisation, ink and cardboard edge, also based on Vlaminck reproduction. Student work.

38 Exercise in variation, pencil, still life theme. Student work.

Exercises in variation

Try exercises in variation (38, 39). Having observed and sketched an object, say an old car in a junk yard, draw it a number of times with the one medium. Vary it each time. Produce a series of studies. Try changing the types of lines you use, the amount of detail you include, the textural effects you obtain. Let your drawings range from a detailed realistic represent-ation to an abbreviated abstraction. Now change to a different medium, to undertake a second series of experimental studies and variations on the theme of the old car. Combine media, if you like. There is virtually no limit to these series exercises in variation which you can plan, and you can learn a great deal about using your art materials.

Exercises in directed observation

Plan exercises in directed observation. Set up still-life arrangements, using everyday objects such as bottles and vegetables (40). Use them to develop your visual efficiency. Train your-self to see the basic structural lines and visual relationships, those parallels, continuations and

39 Exercise in variation, wash over wax crayon, still life theme. Student work.

40 Exercise in observation, charcoal and ink, still life theme. Student work.

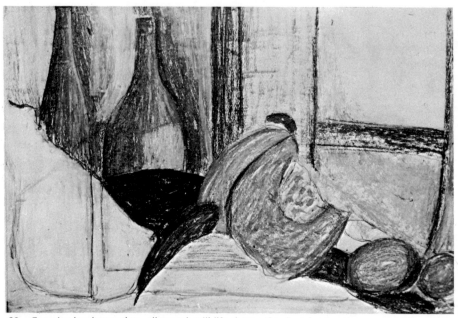

41 Exercise in observation, oil pastel, still life theme. Student work.

affinities we discussed earlier. Incorporate these in the drawing you make of the still-life arrangement so that a soundly-structured and better drawing results. Use pencil and pen and ink together (and improvised tools) — the use of combined materials encourages freedom and adds interest. Work outside, too — in the garden, in the country, by the beach. All kinds of subject-matter provide opportunities for exercises in directed observation.

Exercises such as the ones indicated — and others which you can devise yourself — are basic to drawing efficiency. Before he can write a novel, a writer must know something of the nature of language. Likewise, before you can use your drawing materials efficiently, you must learn something of the nature of drawing. And while you are learning this, you are learning a great deal about art generally — for the concepts, attitudes, skills and techniques you are acquiring here can be applied in other fields of art activity.

A Five-Step Approach

Much of what we have outlined in previous pages can be summarized as a basic approach to drawing and art in general — five essential steps of procedure or action, if you like — as follows:

1. *directed observation* — the trained, controlled use of vision to analyse what you see, to penetrate surface appearances, and to detect fundamental characteristics;

2. *identification of relationships* – the developed capacity to perceive basic structural and visual relationships, and to use these as a basis for a soundly-structured representation or interpretation of the subject-matter;
3. *selection and rejection* – the developed judgement and discrimination that enables you to select significant forms and details for inclusion and to reject the unnecessary and the insignificant;
4. *pictorial equivalents* – the developed ability to invent or devise the most appropriate shapes, symbols, lines and marks to represent the things you have visualised; in other words, the ability to translate visual and mental images into pictorial forms;
5. *definition through accent* – the developed response and judgement that enables you to strengthen and enrich your statement by the addition, in the final stages, of those telling accents and definitive touches that turn an ordinary communication into a convincing or even dramatic drawing.

It must be emphasised that this five-step approach is not offered as a sure recipe for success. Success can never be guaranteed. But it is a useful, safe approach for a student developing his abilities and, perhaps, feeling his way, not quite certain of an approach. But, like all rules of procedure, it can be broken or even abandoned when you have mastered the basic techniques, when you have become competent and confident, and when you know what you are doing. By then, however, you will have developed your own approach which, of course, is the right approach for you. And out of this approach will emerge your individual style. This cannot be taught. It can only be developed. The purpose of this book simply is to help you lay the necessary foundations.

2

Drawing with Pastels and Crayons

The general approach to drawing with pencil and ink outlined in Chapter One applies equally, of course, to forms of drawing using other media. This chapter, in fact, becomes a continuation and extension of Chapter One. You should read both chapters in conjunction. The purpose of Chapter Two simply will be to survey additional drawing materials, particularly ones involving colour, and to describe appropriate techniques and activities for their use. Because some of these techniques are common and frequently used by young children is no reason why you should reject them as childish. You are expected to work at a much more advanced level. These activities still have a place in your art programme, and no matter how old you are, an adventurous, experimental, creative use of the materials involved can contribute much to your technical experience and art knowledge generally.

Keep in mind all the time, however, the continuing need to see and to understand what you see, to detect relationships, and to devise satisfactory pictorial equivalents. Engage in planned exercises of the kind indicated in the last chapter so that you develop these abilities with the new materials. Good drawing remains good drawing, regardless of medium. Don't forget the basic things just because you are now using colour.

We shall now describe some additional drawing activities you might like to try. The few selected are regarded merely as typical; they do not exhaust the range, for there are many others. But try activities like these to give variety and breadth of experience to your art programme.

Pastels

Pastels (42) form one of the most common drawing media; they are widely used — and mostly ill-used. Normally they are used in a simple, direct drawing technique on paper of regular size and texture, and even of colour. As with the common pencil, however, few students subject their pastels to a thorough exploration to discover the range of their graphic possibilities. Try to obtain a set of artist's quality pastels (42:3) which come in sets of 24, 36, or 72 sticks. You will be surprised at the difference in quality and performance between these pastels and the ordinary cheap variety (42:1).

First, find out what you can do with pastels. Experiment with the full range of strokes possible — from a gentle gliding or quick jabbing with the end or point to vigorous sweeps with the broad side of the stick. Discover their capacity to cover large areas and infilling with brilliant colour masses. Discover their possibilities for linear, textural and tonal effects. Blend colours on the paper. Superimpose colours for intense and vibrant contrasts. Scumble them for soft and subtle tones. Mingle colours and soften edges by rubbing them with a finger, a rolled paper stump, or a worn bristle brush. Try adding definitive accents with brush and poster paints.

42 Pastels. 1—traditional pastels in packet; 2—traditional pastel and end section; 3—set of artist's pastels in wooden box; 4—artist's pastel and end section; 5—fixative spray in pressure can; 6—hinged metal diffuser for mouth spraying.

Above all, experience a variety of papers. Get away from a uniform size and colour. Have you ever tried using pastels boldly and vigorously on paper 30 inches by 20 inches? Try the rough side of large litho paper. Experiment with papers of different sizes and textures. Try the full range of colours in cover paper. Try various cards and boards such as triplex boards. Rough and grained papers can be exploited to contribute to unusual effects. Work on coloured grounds, both strongly coloured papers such as cover paper, or merely tinted papers like tinted newsprint. Often striped and printed wrapping papers lead to novel and interesting pictorial effects. If you have trouble getting the pastel to take on these papers, try dampening the surface first. Don't allow the ground colour to dominate your drawing, but often small untouched areas of coloured or printed paper, allowed to show through your applied pastel, can add a richness and liveliness to the surface quality. Occasionally try working on fabrics such as velvet or silk stretched tightly across your drawing board.

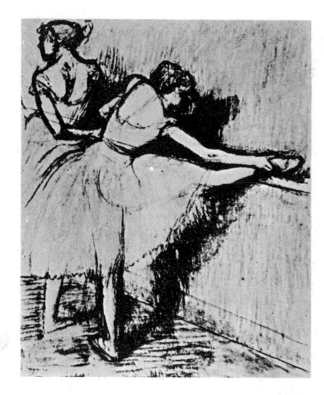

43 Drawing, pastel, by Degas (1834–1917).

Generally, there are two main approaches to the use of pastel, both of them acceptable. When the effect produced is essentially linear in nature, even though there may be some areas of colour, then you are using pastel as a drawing medium (43). But when the end-product shows masses and superimposed areas of colour which obliterate the linear arrangement, the pastel is being used virtually as a brush and paint, and it becomes a painting medium (44). The French call this activity 'pastel painting'; the great French artist, Degas, strictly speaking, 'painted' in pastels. But if you want to appreciate the characteristics and possibilities of pastel as a medium and the peculiar charm of its expression, study his drawings and paintings.

In practice, you will find pastels are somewhat messy to use and easily smudged. Therefore, completed studies and drawings which you want to keep either should be sprayed immediately with a fixative (42:5, 6) or set in a stiff matt mount and displayed under glass.

The cheap pastels commonly used are a hard, rather unresponsive medium lacking the pictorial possibilities and flexibility of a fluid medium like paint. These disadvantages can be largely overcome by using the pastels on wet paper so that they are transformed from a dry to a fluid medium, the use of water having the additional advantages of binding the pigment particles to the surface of the paper, thus reducing smudging, and generally intensifying the colours used. The paper should be well wet. There are a number of ways of wetting the paper,

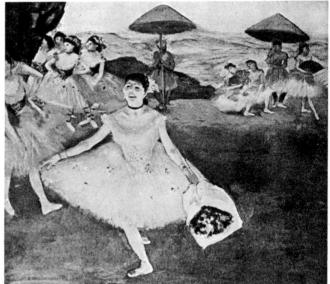

44 Painting, pastel, *'Dancing Girl Thanking Her Audience'* (1877), by Degas.

but you will find a synthetic sponge easy to use, and it can be kept close at hand to wet the paper as it dries out. Try this technique on large sheets of paper, and use your pastels boldly.

The use of pastels on wet paper remains a simple, direct means of communication. As with the dry technique, both the end and side of the stick should be used, and you should try both linear treatments and mass effects. The finished drawing, however, because of the wet technique, should show some of the surface characteristics of a fluid medium.

Oil Pastels

Oil-based pastels (45), a recent addition to the range of drawing media, possess several advantages over the dry pastel. They are soft and responsive to use, blend freely, do not smudge, and need no fixing other than a light polishing with a soft cloth. They come in an attractive range of strong colours which do not fade or change. They allow a much freer approach to colour work than the traditional pastels. By using them firmly in superimposed applications and strokes, you will find you can achieve surface effects somewhat similar in appearance to those of oil paintings (46). They can be used on a wide variety of surfaces including paper of all kinds, cardboards, canvas, cloth, wood, plaster sheets, and even stone.

Drawing with oil pastels is simple, personal, direct. Make your drawing directly on the paper with a minimum of blocking-in, and use the oil pastels in the full colour range (47). Experiment with them to discover their wide range of possibilities. Try papers of different sizes, colours, and textures. Explore ways of applying and superimposing colours, and suggesting detail. You can obtain blendings and colour mixtures by rubbing with your finger or a paper stump.

45 Oil Pastels.

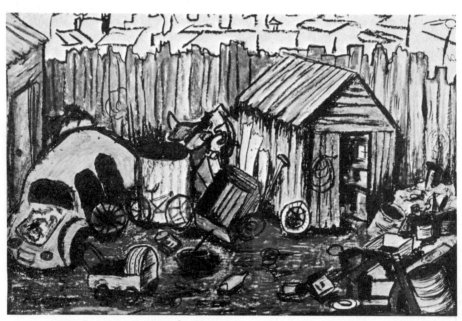

46 Drawing, oil pastel. Student work.

47 Drawing, oil pastel. Student work.

Try your oil pastels in combined and resist techniques. Because they have an oil base, oil pastels will repel or resist any water-based medium such as water colour or diluted drawing ink, so by using a soft brush you can apply contrasting colour washes to parts of your drawing or over the whole surface without destroying your linear arrangement; this allows you to achieve a more complex and richer colour treatment, and a more interesting drawing. Again, transform your oil pastel drawing by going over it with a stiff bristle brush moistened in an oil solvent such as turpentine or lighter-fluid; the solvent softens and blends the colours, giving a brush and wash effect.

Because they do not smudge easily, oil pastels are particularly useful for outdoor sketching and for making preliminary studies. Next time you visit the country or the beach, take a box with you; use them for quick sketching and rapid impressions.

Crayons

Although inferior quality crayons are available and should be avoided, good quality wax or oil crayons – those made and clearly labelled by a reputable manufacturer of art materials – are a versatile drawing medium with a wide range of additional activities, similar to oil pastels. For general drawing and free-hand work, both materials employ the same direct technique. Indeed, most of what has been said previously in this chapter about drawing with both dry and oil pastels can apply to crayons; in many ways they are related, forming a group or family of graphic materials.

48 Crayons. 1—wax drawing crayons; 2—marking crayons.

Good quality wax crayons (48) are soft, produce full strokes in rich colour, cover large areas easily and quickly with a liberal deposit of pigment, will not smudge, can be polished if desired to a glossy finish with a soft cloth or cotton wool pad, and are water-resistant. Wax crayons can be used on papers of all kinds and boards such as triplex board and surface board, but very thin papers or excessively textured papers can prove frustrating because you will find it difficult sometimes to achieve an even, rich colour application. Oil crayons, like oil pastels, can be used on a wide variety of surfaces, including porcelain, plastic and even glass. Both the end and side of the crayon can be used, and firm pressure is needed to obtain maximum cover and full colour richness. Colours can be applied in superimposed layers so long as you apply a softer and darker colour over a light, harder colour, and you can blend and mix colours freely by working the harder, lighter colours into the softer and darker colours. Used boldly and firmly, crayons can produce highly-coloured, richly varied expressions, combining the appeal of a brilliant colour range with an attractive matt surface.

Because they are soluble in turpentine or lighter-fluid, wax crayons can be used for several additional activities. Fully dissolved in turpentine, they can be applied in liquid form with a brush to produce a brush drawing or painting. Again, after your crayon drawing has

been completed, you can go over it with brush and turpentine, slightly dissolving the crayon strokes, to produce an unusual fluid effect. Alternatively, if you dampen your paper with turpentine, the end of the crayon will dissolve as it makes contact with the dampened paper, producing a drawing of exceptional colour brilliance. Because of their wax base, you can use crayons in all the normal 'graffito' (50) and resist techniques involving over-painting with water-based media, such as crayon and paint, crayon and ink, and batik, all of which are described more fully later in this chapter.

One other kind of crayon which must be mentioned is the soft, splendidly responsive conte crayon (19) used by artists. This French crayon comes in black, red or sanguine, and white sticks, rectangular on section. While more expensive than wax crayons, conte crayon is a delightful drawing medium, easy to use and adaptable, permitting a considerable range of manipulations for linear, mass and textural effects, and tonal gradations. You will find it an excellent medium for making preliminary drawings and clarifying studies. Try to obtain a box or some sticks of conte crayon; you should enjoy the experience of drawing with it.

Coloured Pencils

While the ordinary coloured pencil can be used for most of the activities outlined In Chapter One for the black or graphite pencil, there are available specialized kinds of coloured pencils

49 Drawing, coloured pencils. Student work.

which have a place in an art programme and add variety to the range of drawing materials. The best-known of these are the water-soluble coloured pencils, or aquarelles as they are called, which you can use as coloured pencils in the normal way, or you can use them on wet paper, or gently work over them with a wet brush, to obtain quite different linear effects.

Coloured pencils are available in an attractive range of bright colours, in packets or boxes containing multiples of 12, up to 72 pencils. For best results, use them on a thick, hard-surfaced paper such as cartridge paper or smooth water-colour paper, or a thin pasteboard.

Additional Activities

The direct, one-stage drawing techniques generally used with pastels and crayons can be extended into combined techniques involving a sequence of several steps and the use of water-based media. Though more complex in nature, these techniques remain drawing activities so long as your end-product is linear in treatment and appearance. All of them offer you opportunities for further creative experiences and provide additional means of personal expression.

The popular scratch technique (50) or 'sgraffito' as it is called in a number of places, was mentioned briefly on p. 24. Both oil pastels and crayons permit an application of two separate, superimposed layers of colour. The technique involves the making of drawings by incising into or scratching away portions of the upper layer to expose or reveal the underlying application of crayon. Drawings can be made using either a white ground of wax crayon or candle to give a white-lined effect, or a coloured ground to produce a full-colour result. Make sure your white or coloured ground is applied firmly to achieve a liberal, even distribution of pigment for maximum contrast later. Then apply a generous layer of another colour, normally darker, to completely cover this ground. You can use superimposed layers either of oil pastel or of crayon, or you can combine them; try all ways to explore the range of effects that are possible. Alternatively, you can use an upper layer of opaque paint such as a casein emulsion poster paint, or make a mixture of your own using black powder colour, soap or soap flakes, and water, stirred to a creamy consistency. If you use paint, allow it to dry thoroughly before you commence the next stage. Now scratch, scrape and incise your drawing into this top layer with a variety of pointed or sharp-edged tools such as a nail, nailfile, steel nib, wire paper-fastener, pocket knife, or the edge of a small coin, aiming for surface enrichment and a diversity of linear and textural effects. The underlying light or coloured ground will stand out in a bright, luminous contrast to reveal your drawing. By experimenting freely, you will discover an almost unlimited range of surface qualities, extending from fine, intricate detail incised with a needle or nib to broad effects scraped with the blade of a knife.

Another group of activities is based on the principle that certain materials are repellents, so that a resistance occurs. Reference to the crayon-and-wash technique, using an application of transparent water-colour or diluted drawing inks gently applied with a soft brush over a resistant crayon drawing, has already been made on p.49. With the crayon-and-ink

50 Drawing, scratched or graffito, wax crayon. Student work.

technique, you can vary this drawing activity quite simply by using opaque Indian ink instead of transparent water-colour, to produce an entirely different effect. The wax crayon drawing naturally repels most of the ink which covers, however, all parts of the paper not touched by crayon. The result shows a combination of black background areas, bright crayon drawing, and tiny residual quantities of ink on the crayon. The deep black emphasises the brilliance of the coloured crayons, creating strong contrasts and dramatic colour effects. Drawings produced by this technique often show a distinctive and charming pictorial mood or feeling.

An additional and somewhat more complicated drawing activity that you could explore is a simplification of the traditional Indonesian 'batik' technique used for creating intricate dyed patterns on fabrics. The technique uses the resist principle, and you will need a white wax crayon or plain white candle, watercolours, and a soft brush. Making a drawing in white wax crayon or candle thickly applied, preferably on a white paper such as cartridge paper. Now cover the whole sheet with a transparent watercolour wash, which the white crayon repels.

When this first wash dries, add to your white crayon drawing; include additional lines and areas, details and decorative effects. Then apply a second wash, using a different colour, over the whole sheet or portions of it, and you will find that this wash will be repelled by both applications of crayon. You now have the combined effect of the original white crayon drawing, the first coloured wash where it has been isolated or sealed off by the second application of crayon, and the superimposed transparent washes where there is no crayon at all. Continuing in this fashion, crayon additions followed by watercolour washes, you can make intricately detailed and richly patterned drawings in which the linear treatment grows progressively more complex. A brief period of thoughtful experimenting will demonstrate the creative possibilities of this less familiar drawing activity.

So much for drawing. We have dealt with some of the more useful drawing experiences considered appropriate to a book of this kind, but there are many others available, and you would be wise to broaden your field of experience as much as possible.

Chapters One and Two have outlined an approach to drawing and indicated activities which, if you follow them conscientiously, should exercise and strengthen the basic drawing skills of seeing, thinking, analysing, creating the necessary pictorial equivalents, and interpreting the subject-matter with some technical competence and individuality of expression. But it must be emphasised that these skills are acquired skills, and like all acquired skills they must be practised constantly to be maintained at full efficiency. If you genuinely want to become proficient at drawing – and remember its fundamental importance to all other areas of art production – you must constantly practise the skills involved. Just because you become attracted to painting or sculpture, for instance, don't neglect or abandon your drawing techniques. The great English sculptor Henry Moore fills many sketch books (136) with drawings and jottings and quick impressions. Very often professional painters attend drawing classes just for continual practice and the experience of working with others.

You will need this practice, too.

3
Watercolour Painting

The term 'watercolour' for the purposes of this book refers to those techniques that employ water-based or water-soluble paints. This chapter is concerned, then, with painting both in the traditional, transparent watercolour medium in which the white paper shows through the applied colour and also with the several opaque variations such as poster colours and tempera colours.

But before we proceed with any discussion of watercolour painting, several characteristics of painting generally should be clarified. Near the beginning of Chapter One, an important distinction between painting and drawing was made, and it seems worthwhile to restate it here. A painting consists essentially of *areas or masses* of pigment, placed side by side or superimposed. In a watercolour painting, for instance, the pigment is transported in water and the areas of colour are manipulated and controlled by soft hair brushes. A painting, therefore, is basically an *arrangement of colours*, with or without meaning. Without colour, there would be no painting. Drawing, on the other hand, need not concern itself with colour; a finished drawing can exist without any colour at all, with no loss in meaning or impact. But painting is absolutely dependent on colour. In addition to its dependency on colour, however, painting is also dependent on drawing; most kinds of painting utilize *drawing skills* and materials at some stage, either as preliminary working drawings and clarifying studies, or in the initial blocking-in and distribution of forms and masses on the surface to be painted, or in subsequent stages in the evolution of the finished product. Very few watercolour paintings, for example, are made directly on the paper without the aid of a light, pencilled sketching-in of the subject. Because of this dependency on applied colour and drawing skills, therefore, the practice of painting normally becomes a much more *complex activity* than drawing, requiring more time, more effort, and additional materials.

Two words used constantly in any discussion of painting are technique and style, and they refer to quite different things. *Technique* concerns the artist's craftsmanship, his knowledge and competent management of techniques and materials; in other words, his mastery of his 'tools of trade'. *Style*, however, refers to his personal manner of expression, the personal touch he reveals in his use of materials – the revelation of his personality, if you like – which distinguishes his work from the work of all others, so that we can talk of the style of Rubens or the style of Cezanne, identifying readily the works of these masters by their stylistic characteristics.

But without a sound basic technique it is unlikely that any artist can ever develop a working style of his own. And even if he masters the basic techniques, there is no certainty that a uniquely personal style will emerge. We can only hope that one does. For a personal style cannot be taught; it can only be encouraged. But techniques can be taught, and, indeed, should be. You will never progress far in art until you have learned some of the basic techniques. The several kinds of painting have their own basic procedures and methods.

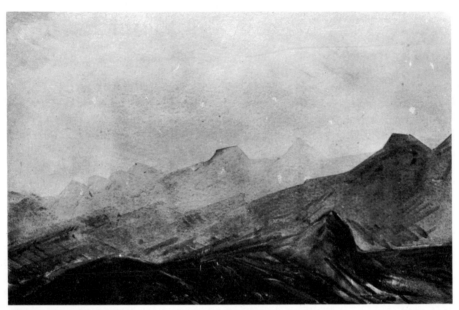

51 Watercolour, transparent, detail from **Plate 1,** *'Flinders Ranges'*, by John Borrack.

52 Watercolour, opaque, detail from **Plate 2,** *'Pine Grove'*, by Gordon Speary

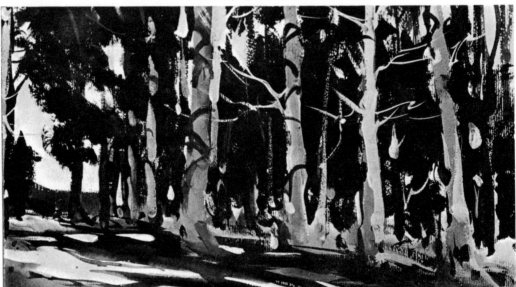

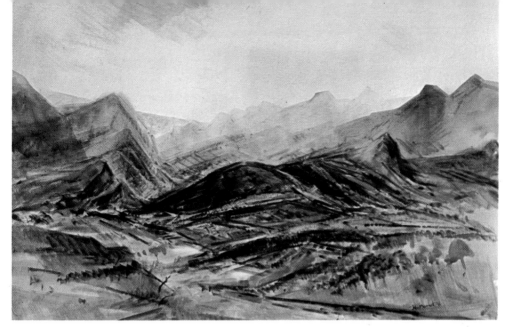

Plate 1. WATER COLOUR, Transparent. *'Flinders Ranges'* by John Borrack, In the possession of the artist. Showing the diluted paint, superimposed washes, use of the white paper surface, absence of white pigment, crisp spontaneous technique, and the fluid appearance of pure watercolour.

Plate 2. WATERCOLOUR, Opaque. *'Pine Grove'* by Gordon Speary, in the possession of Coburg Teachers College. Showing thicker opaque paint, the concealment of the paper, overpainting, and the use of white pigment for lighter tones and superimposed detail.

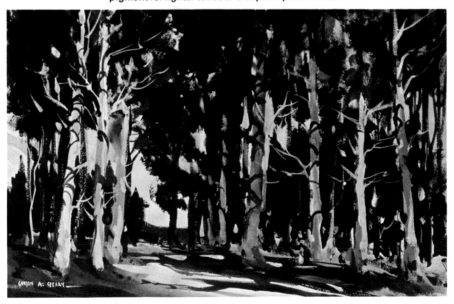

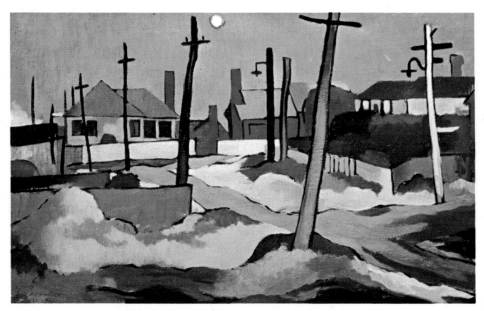

Plate 3. OIL PAINTING, Wet-in-Wet. *'Highbury Avenue'* by Max Dimmack, in the possession of the artist. Showing preliminary black-lined drawing, priming, underpainting, and subsequent colour areas applied wet-in-wet and blended in.

Plate 4. OIL PAINTING, Alla Prima. *'Still Life'* by A. W. Harding in the possession of the artist. Showing single application of paint without underpainting or glazing, direct technique, free brushwork, and intensified colour passages.

Plate 5. LINOLEUM PRINT, Coloured. *'Still Life'* by Kenneth Hood, in the possession of Max Dimmack. Showing the use of several colour blocks, variety in cutting, textural interest, superimposed colour areas, and a controlled colour registration.

Plate 6. COLLAGE, Flat. *'Yellow Landscape'* by Janice McBride in the possession of Mrs R. J. Guy. Showing the pasting technique, use of coloured papers, both cut and torn edges, and a sensitive use of shape, colour and texture to create a striking representation of the subject-matter.

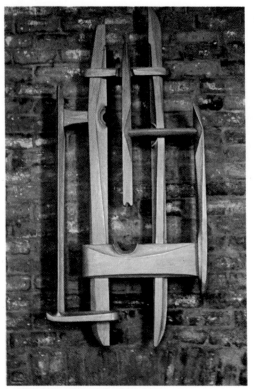

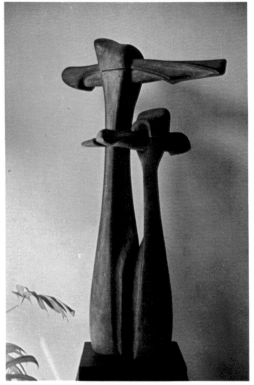

Plate 7. WALL SCULPTURE by
Clifford Last in the possession of
Mr J. Melody.

Plate 8. FREE-STANDING
SCULPTURE by Clifford Last in the
possession of the artist.

Showing a developed sensitivity towards the materials, respect for natural
forms, elegance of style, disciplined carving technique, coherent relationship
of parts, and an appropriate surface treatment.

Plate 9. A SCULPTOR'S STUDIO. Clifford Last at work in his studio. Showing the
sequence of production — at left, a piece of timber, drawings for sculpture, maquettes,
a work being carved and the tools used, a completed work and additional equipment
in the adjacent storeroom.

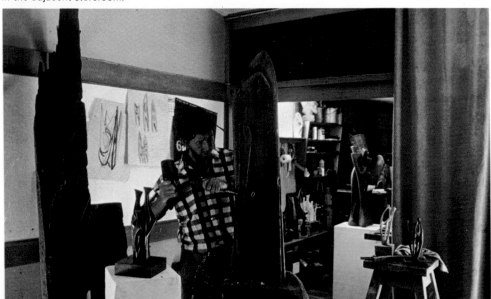

Compared with other kinds of painting, watercolour painting posesses certain advantages. It holds fewer technical difficulties and is less time-consuming than oil painting. The equipment it requires take up little space, is readily portable, and is easily cleaned after use. A considerable financial outlay is not necessary, and for a minimum expenditure you can experience the satisfaction of successful creative effort in a challenging and expressive medium.

Watercolour may be applied in various ways, from thin transparent washes (51, Plate 1) of colour to thick applications of pure pigment, but as thick applications of paint are most certain to crack and flake, pure watercolour is applied more appropriately in thin washes. If you want to work with thicker applications of watercolour you should use opaque colours (52, Plate 2).

Let us consider at this point the main kinds of watercolour painting that you are likely to encounter as art students, commencing with the traditional watercolour technique.

Pure or Transparent Watercolour

In this introduction to pure watercolour painting, we shall discuss four main areas of information, namely, paper, paints, brushes, and methods of using the paints. Additional information on the characteristics and display of successful watercolours is also included.

Paper

The normal support or surface for watercolour painting is paper, and the type of paper you use is probably of greater importance than the quality of the paints. For you just can't use any sort of paper; you can't work, for instance, on excessively smooth or thin paper. Watercolour painting requires a substantially heavy, thick, absorbent paper with a marked grain or texture, and normally the thicker the paper the greater the texture it possesses. The very best watercolour paper is made – often by hand – from linen and cotton rags, in three textures: rough, medium, and smooth respectively (53). Many watercolour papers are pure white, giving a maximum surface luminosity under the transparent colours, and the tiny portions of the paper not covered with colour add a sparkle to the finished painting which is one of the eye-pleasing characteristics of the technique. Every paper has a right and a wrong side, and you should work always on the right side. Good quality watercolour paper usually incorporates a watermark so that when the sheet is held up to the light the watermark can be read correctly from the right side. Even ordinary cartridge paper has its right side, which you should use; if you tilt a sheet of cartridge paper so that the light strikes its surface at an acute angle, you will notice that one side has a smooth, mechanical texture which results from the manufacturing process, while the other side is rougher, with an irregular texture. This rougher side is the correct side for drawing and painting. Most of the papers you will use tend to buckle when water is applied, thus making it almost impossible to control the flowing colours and washes. To reduce this tendency, the paper needs to be strained or stretched (54). To do this, soak the sheet in water by dipping or by saturating both sides with a sponge (54:1).

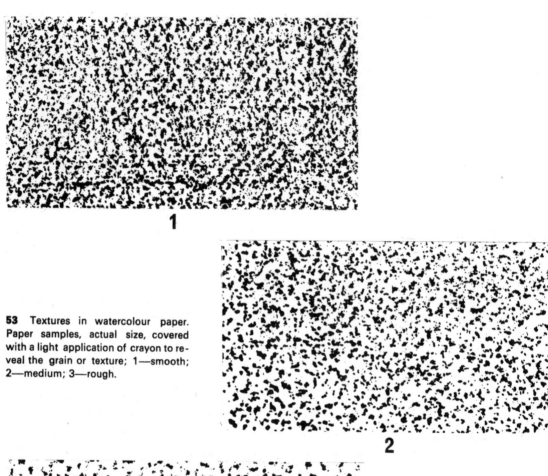

1

53 Textures in watercolour paper. Paper samples, actual size, covered with a light application of crayon to reveal the grain or texture; 1—smooth; 2—medium; 3—rough.

2

3

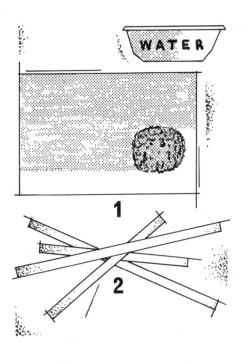

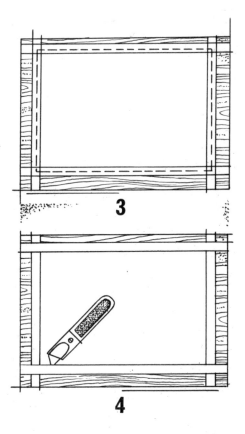

54 Stretching watercolour paper, 1—soaking the paper with clean water; 2—gummed paper strips. 3—the wet paper fixed to the board by gummed strips along all four edges; 4—cutting the paper free (after the painting is finished).

Then place the sheet flat on a board, taking up the excess water with a sponge or blotting paper so that the paper will dry evenly. When all the wrinkles or buckles have disappeared, fix all four edges of the paper to the board with gummed paper or tape (54:3). When the paper is completely dry and tightly flat, you can use it.

Watercolour can be used on tinted or coloured papers, but as pure watercolour painting uses no white pigment, depending entirely on the white of the paper to produce the light areas and pale tones, the advantage of working on white paper becomes obvious.

The paints

In watercolour painting the paints used are compounded of high quality pigments added to the moisture-retaining properties of glycerine and the binding qualities of gum. Each individual colour, however, has its own recipe to ensure the best working properties. The moist colours are readily soluble, and in the traditional transparent watercolour technique, water alone is required as the vehicle in transferring the diluted colour from the palette to the

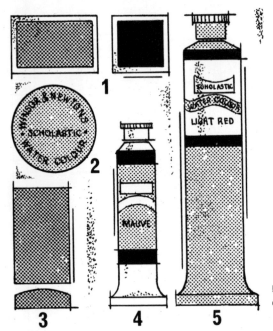

55 Watercolours. 1—pan and half-pan; 2—round cake; 3—tablet; 4—small tube; 5—large tube.

paper. Watercolours are marketed in cakes, pans, or tubes (55); pans are probably more economical for you only use what you need, but tubes probably are simpler to use, particularly if you are using quantities of colour at the one time. A metal box fitted with pans of colour and mixing compartments is very convenient, especially for outdoor work. It is a good plan to use two water jars, one in which to wash your brushes and the other from which to obtain the clean water to mix and dilute the colours. Dirty water, of course, means dirty colours. Student or scholastic quality watercolours in tubes are manufactured for those who do not need the exceptionally high quality or cannot afford the more expensive artists' quality colours. You will find their colour qualities and general working properties quite satisfactory, however, for your requirements at this stage.

If you purchase a set of watercolours, you need not limit yourself necessarily to the range of colours that comes with the box. Select your own range and have the pans changed accordingly. If you use tube colours, of course, you can reflect your own taste and preference

in the colours you choose. A range of colours – in students' quality – similar to the colours indicated on p. 87 for oil painting should prove adequate initially. But ignore the references to white paint. You won't need any white paint for transparent watercolour work.

Brushes
Brushes are an important and sometimes expensive item of equipment, and the best brushes for watercolour painting are made from hairs from the tops of the tails of small furred animals

56 Kolinsky Sable. Kolinsky sables, found in the inner region of Siberia, supply the hair, taken from the tops of their tails, which is used in the manufacture of the finest quality watercolour brushes.

called sables, (56) which live mainly in Siberia. Fine red sable hair is soft, durable and resilient and gives a fine point. Brushes of inferior quality may be made from mixtures of sable and ox hair, ox hair, or squirrel hair. You should try always to use the best brushes you can obtain; there is no substitute for a good quality brush. You will need a range of brushes (57) generally in large sizes, 6 up to 10, mostly round and pointed, with two or three flat hair brushes for laying-in washes and large areas of colour, as in skies. Get used to working, right from the start, with thick brushes which take up a generous quantity of paint. In watercolour painting, work always with a full brush of colour, whether you are working on fine details or in large areas. You will find that small brushes are rarely required; a good quality thicker brush gives you as fine a point as you will need. Care of brushes is important. A good brush, properly cared for, will keep its shape and give you years of reliable, consistent service. Immediately after use, brushes should be thoroughly cleaned in soap and water until no colour remains. Then rinse them in clean water, shake out the excess water, and stand them on their handles in a glass jar to dry, and so that you can see each brush as you use them. Never allow paint to clog the end of the metal ferrule; not only is it difficult to wash out, but an accumulation of dried, compacted paint in this region prevents the brush from resuming its true shape

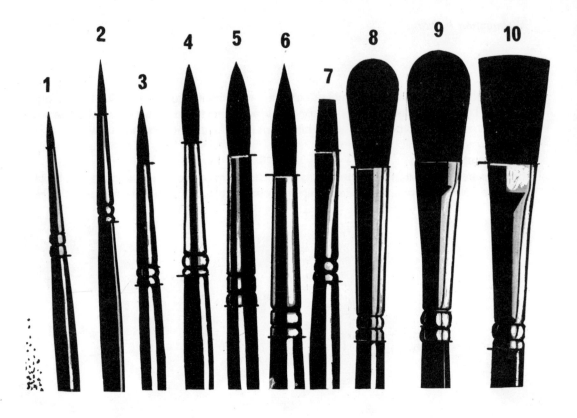

57 Watercolour brushes (*actual sizes*). 1—pure red sable, size 1; 2—pure red sable, extra long point, size 2; 3, 4—pure red sable pencils, sizes 5 and 6; 5—blended hair, round size 8; 6—brown ox hair, round, size 10; 7—pure red sable, $\frac{1}{4}$-inch flat, one stroke brush; 8, 9, 10—wash or sky brushes (in squirrel hair; small, large, extra large; flat or domed).

(58:1). If you don't intend to use your brushes for some time, store them flat, when they are quite dry, in a box or tin, and the inclusion of naphthalene or moth balls protects them from damage by moths. Avoid ill-treating your brushes. Don't store them in containers or drawers that are too small so that the shape of the hair becomes distorted (58:3). For the same reason, don't leave them standing in water unnecessarily or for long periods (58:2). Don't stab, jab or scrub roughly with a good brush; this only fractures or damages the hairs (58:4). Brushes can never perform satisfactorily if you subject them to this sort of treatment.

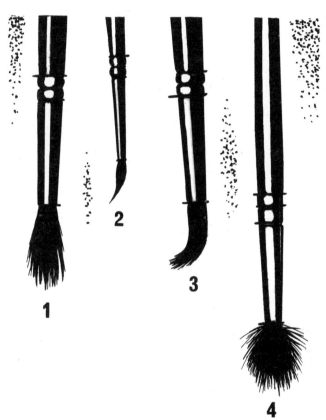

58 Damaged watercolour brushes. 1—compacted pigment resulting from inadequate washing prevents hair from resuming its true shape; 2—distortion to brush left standing in water for prolonged periods; 3—distortion caused by container that is too small; 4—fractured hairs resulting from jabbing and similar rough usage.

It has been said that watercolour is the beginning and the crown of all painting technique. Technically simple, watercolour is difficult in practice, requiring an understanding of the fluid nature of the medium, a clear idea of what is to be attempted and how it is to be accomplished, an experienced and sure touch, a broad, simple approach, concentration and speed. The production of a successful watercolour, therefore, is something of an artistic achievement – as you will discover. But it is a splendid medium, thoroughly worth the time and practice involved in mastering the fundamentals.

A General Approach

Before we outline basic techniques, a general approach to the making of a watercolour painting should be considered. An initial pencil blocking-in is essential, but do this lightly in soft pencil so that the lines can be left without spoiling the effect of the finished painting. When the blocking-in is completed, wash over the surface of the paper with a soft thick brush and clean water to remove the excess graphite and to reduce smudging. You should work sitting at a table, with all your materials conveniently arranged nearby. Allow the table to take the weight of your board and paper, but hold them at an angle which can be altered as required to control the flow of the liquid colour. The steeper the angle, of course, the faster the flow of the colour, with less settlement of pigment in the texture of the paper and a lighter colour as a result. If you are using colours in pans, moisten them all first with a drop of clean water so that your colours are ready for immediate use. Mix your required colours on a plastic or porcelain palette (59) or in the mixing compartments of your paint

59 Watercolour palettes. 1—white divided slant tile, 3, 4 or 6 divisions; 2—white slant tile, end divided; 3—white plastic 6-well palette; 4—china plate, whole or half.

box. If you want clean, clear colour effects, keep your colours clean at all times, both in the box and on the palette. As a rule, avoid mixing colours on the paper unless the mixing results from superimposing clear washes. Always mix more colour than you think you will need; it is better to be sure than sorry, and the excess paint is available for a second application, if needed, or for additional colour mixing. To lay a wash (60), flood the colour quickly and

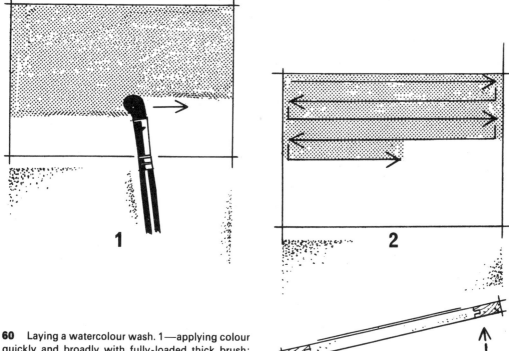

60 Laying a watercolour wash. 1—applying colour quickly and broadly with fully-loaded thick brush; 2—the brush movements; 3—drawing board held on required angle to control rate of flow.

broadly on to the paper with a fully loaded thick brush, keeping the board at the required angle. Allow for some waste. A good wash should use colour generously; you can remove the excess paint which accumulates at the bottom of the paper with a rinsed brush or a clean cloth. Don't be so mean in your colour application that you have to go over a wash un- necessarily, robbing it of its spontaneity and evenness. Work over the whole surface of the paper, strengthening all parts of the painting progressively. Work up from weak to strong colours. Pale colours can be strengthened, if desired, by further applications of paint; areas of colour that you consider too dark or strong can be moistened with a clean brush and some of the paint removed. Work rapidly to keep the painting area wet, otherwise your

colour areas will dry too quickly, leaving an unpleasant hard edge or rim around the colour. Never use white pigment with transparent watercolours, and don't mix transparent black with other colours. Black has a place, of course, but it should be used alone or under colours; used over colours it merely muddies them, thus destroying the purity of their effect. Always keep a supply of clean rags on hand, for drying brushes, taking up excess paint, wiping mixing compartments and palettes, and so on.

Techniques
The technique of painting in transparent watercolour can be reduced to three basic methods. The traditional approach, using pure transparent colours – and sometimes called the *English method* (61) – involves the application of untouched, flat washes of colour, layer on layer, until the desired strength of colour is achieved. This method of using watercolour was a distinctly English contribution to the arts, and the more brilliant exponents of the approach

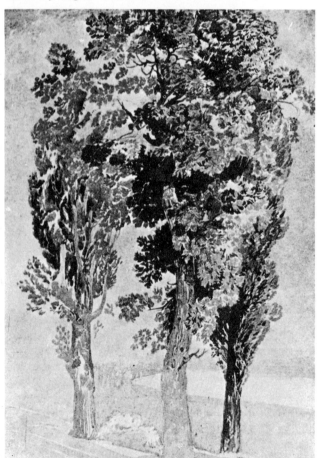

61 Watercolour, in the English tradition, showing superimposed washes of colour, *'Study of Trees'*, by John Sell Cotman (1782–1842).

like Girtin, Constable, Cotman and Turner used it with magnificent breadth, charm, and quiet delicacy. An approach almost the opposite of the English, called the *direct method* (62), probably shows something of an American influence, especially through the early

62 Watercolour, direct method, showing a bold, rapid and direct application of the paint, *'Boat off Deer Isle'*, (1926) by John Marin (1870–1953).

63 Watercolour, wet-in-wet method, (detail), showing the characteristic watery appearance and subtle colour minglings.

watercolours of Marin; it involves using watercolour in one bold, rapid, vigorous, and direct application of the paint, sometimes with emotional effect, to complete the painting. Products of this method show a striking economy of effort, an obvious spontaneity and liveliness, and crisp, clean colour effects. The third technique is called the *wet-in-wet method* (63). In this approach, the paper to be used is generously soaked with water on both sides and then firmly stretched on a board, which again is held on a slope. After the surplus water has drained off, the painting is made directly into the wet surface with the brush liberally loaded with colour but containing a minimum of water. The colours run and blend softly into each other, producing vague forms, subtle colour minglings, and a watery appearance frequently admired. When the colours are dry, it is permissible to add significant details and definitive accents to strengthen both the composition and the pictorial statement. A simpler variation of the wet-in-wet technique requires a dry paper. A thick soft hair brush generously loaded with colour should be used, and the colours are allowed to run into each other as the paper surface becomes wet. Additional colours can be dripped into existing wet areas to further complicate the colour mingling, And, again, strengthening touches usually need to be added after the colour applications have dried.

Characteristics

The essential characteristics of transparent watercolour painting are unlike those of any other medium. The very nature of the medium makes inevitable transparent, watery, fleeting effects of great spontaneity and charm. And the broad, simple, rapid manner of handling

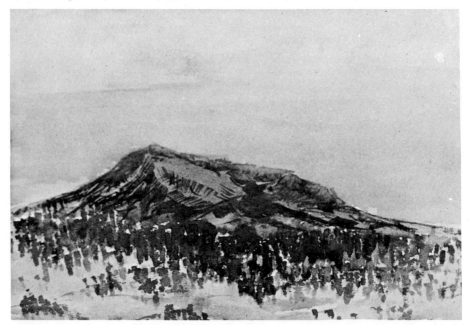

64 Watercolour, transparent. Student work.

the colour yields crisp, animated surface qualities that are unique in the arts. But the dominant characteristic of the watercolour technique surely is its power to suggest rather than to represent or to reproduce (64). This suggestive capacity stimulates the imagination of the viewer, inviting him to complete in his own imagination the fleeting and the unexpressed, thus encouraging his active co-operation in the enjoyment of the work.

Opaque Watercolour

There are readily available several opaque variations of the watercolour medium. Experiment with these, for each possess its own characteristics and possibilities, and you will find many reasons and opportunities to use them.

65 Painting, gouache, landscape. Student work.

Designers' *gouache* (65) are moist, opaque colours of great covering power which may be used thickly or thinned with water and applied in a wash using a thick sable brush. While manufactured especially for design work, many of the colours can be used for landscape and other traditional forms of painting. *Poster colours* (66, 67), in tubes, jars, or plastic dispensers, are in some respects similar to gouache; they dry quickly and evenly to a smooth matt surface, come in a brilliant colour range, and they can be used in combination with other media (68–71). *Water-based tempera colours* (72), in powder, liquid, paste, or disc

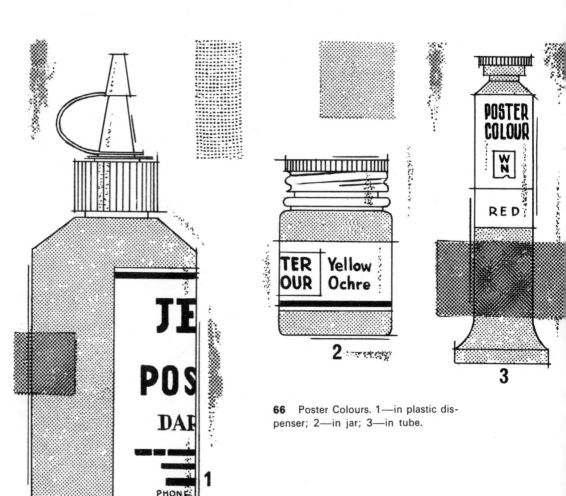

66 Poster Colours. 1—in plastic dispenser; 2—in jar; 3—in tube.

67 Painting, poster colour, showing areas of diluted colour and thick impasto applied straight from the tube. Student work.

form, are thick opaque paste colours, also in a brilliant colour range, which mix readily together in a manner somewhat like oil paints. They can be thinned easily with water and permit a variety of treatments, from practically a thin, transparent wash to the richly coloured, vigorous brush strokes and over-painting normally associated with oil paint. Both poster colours and tempera colours are particularly useful for practice painting, for sketching and preliminary studies, and for large scale picture making where better quality and more expensive paints would be inappropriate. Because these paints are thicker and opaque, almost any kind of paper, except very thin, can be used. Cartridge paper is particularly suitable, and the use of coloured paper, such as cover paper, which need not be completely covered by paint, can add additional colour interest and liveliness to the final effect.

The opaque water-based emulsion colours, (73), such as the German Plaka and the Japanese Hydric colours, are a new and particularly versatile medium which you should try. The colours are ready for use, and seem to combine some of the advantages of both water-colours and oils, so that, diluted with water, they can be used in wash-like applications, or,

68 Painting, poster colour and felt-tipped marker. Student work.

69 Painting, diluted poster colour and charcoal. Student work.

70 Painting, poster colour and pen and ink. Student work.

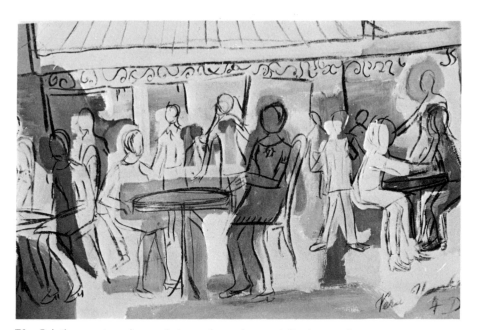

71 Painting, poster colour and charcoal superimposed. Student work.

72 Tempera colours. 1—liquid, in can; 2—powder, in can; 3—discs in white plastic 6-well palette; 4—disc, unwrapped.

they can be applied thickly with brush or palette knife in the full richness of oil painting (74). They come in an attractive range of permanent colours with good covering qualities, and dry rapidly to an even, smooth surface; thus corrections or further over-painting can be completed with the minimum of delay. When dry, the colours are water-proof and resistant to rubbing. Although these colours are soluble in both water and the common oil solvents, brushes need only to be washed in water. Emulsion colours attach to a wide range of supports, so that you can paint on papers of all kinds, cardboard, wood, canvas, fabrics, metal or glass. Like poster and tempera colours, you will find them useful for sketching, for preliminary studies, and for outdoor work. But, being a medium of permanent colours, emulsion paints allow you also to produce finished works of considerable surface quality and rich colour effects.

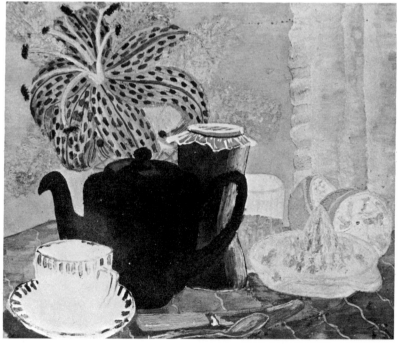

73 Water-based emulsion colours.
1—in jar; 2—in tube.

74 Painting, water-based emulsion colours. Student work.

Useful Exercises

If you have never painted in watercolour – or if you have never achieved much success with it – you would be wise to commence with simple exercises to help you acquire the basic skills and knowledge.

Exploratory exercises

Experimental, exploratory exercises with the brush enable you to discover the full range of possible effects (75). See how many different strokes or marks you can produce using the

75 Exploratory exercise, experimental brush effects. Student work.

one brush. Try this with each of your brushes so that you get to know them and how they perform. Compare the strokes made by a brush fully loaded with colour and one that is almost dry. Try dragging the brush; try rotating it, or even lightly bouncing it or dabbing it on the paper. Try dropping or flicking paint from the brush. Observe these different effects; you will want to use them later. Try two colours on the one brush and two brushes together. Try other technical variations that you can devise yourself. When you have subjected your brushes to a searching exploration like this to discover their possibilities, introduce improvised tools (76) such as a piece of artificial sponge (which you can use for a wide range of strokes and stripes as well as stippled treatments), the edge of a piece of card (which you can press or drag), a piece of stiff string, a feather, a stub of rolled paper, and so on; all of these things produce different effects. Use these additional materials in conjunction with

76 Experimental effects, improvised materials. Student work.

your brushes. Make several sheets of these experimental effects; keep them for subsequent reference and use later in meaningful ways in paintings that you will produce.

Exercises in communication

Now try exercises in communication through brush strokes. As watercolour is a suggestive medium it can communicate through the way the brush is used; the brush strokes themselves convey the intended information. Study the brush strokes of Chinese artists for clear evidence of this. Using a thick brush, then, and one colour only, see how well you can communicate through your own symbolic, spontaneous response to words like crash, explosion, jazz, scream, hush, symphony, carnival, pain, laughter (77). Don't attempt to

77 Exercise in communication through brush strokes. Student work.

draw these topics literally or in a representational way; you must suggest your reaction to the word by the kind of brush strokes or marks or symbolic equivalents that you employ. To complete exercises like this successfully you will have to make your brush work; you will need to use it with understanding and purpose

Exercises in definition
Next try exercises in definition to apply what you have learned about using your brushes. Again use a soft thick brush and only one colour. Indian ink will do, if you like. Try a series of common tree forms in silhouette (78) – just flat applications of paint – but defining each

78 Exercise in definition, silhouette characterizations, brush and ink. Student work.

tree so well by the strokes and marks you use that it can be immediately identified. Visualise the forms clearly in their characteristic appearance; then exploit the possibilities of the brush to reproduce this visualization in silhouette form. Try the same exercise with forms other than trees – common objects and familiar things.

Exercises using the wash technique
Exercises using washes form an essential part of any programme in watercolour, and you will make little progress until you have learned to control and exploit the wash technique. You will need to experiment and to practise continuously. Try flat washes of colour. Then try grading washes by the addition of water to weaken or lighten the colour. Experiment with the angle of the board; watch the effect on the flow of the wash. Try different kinds of paper

with their different textures and surface properties; you will find that some textures hold more pigment than others. Try superimposing washes of the same colour, and of different colours; let each dry first, of course, but take care each time not to disturb the wash underneath. You will soon discover that a wash has to be controlled and correctly applied the first time; uneven, patchy or streaky washes rarely can be repaired. Try washes of strong or saturated colour. Try wet-in-wet techniques with your wash. Try ways of lifting colour; use a rinsed brush, the edge of blotting paper, a piece of cloth. Try scraping into a dry wash with a sharp blade, or even lightly sandpapering. Try washes over other media such as wax crayon, oil pastel, pen and ink, coloured pencil, even black pencil or charcoal. Again, keep records of your experiments for future use. Label them so that you will know how the various effects were obtained.

Exercises in tone and gradation

If by now you are reasonably competent in handling the wash technique, you can try exercises in tone and gradation. In small rectangular panels, wash on a single colour to obtain an even gradation from strong to weak or pale by adding water as you go. Aim for a smooth and gradual transition in tone; try to avoid abrupt and obvious changes. Then make tonal studies in one colour of single, everyday objects like an opened carton, a loaf of bread, a pumpkin, a satchell or handbag, etc. Use the full range of tones from strong colour to pale colour to the white of the paper. Then move on to bigger subjects like groups of trees (79).

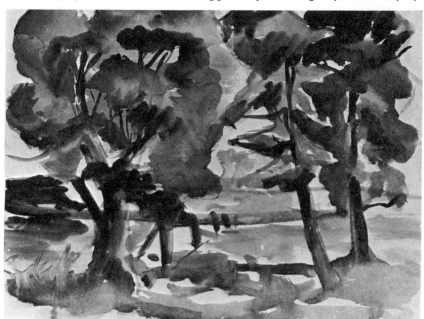

79 Watercolour, transparent, monochrome study.
Student work.

Exercises like this not only develop your perception of tone but also exercise the analytical kind of seeing so essential to the practice of art.

Exercises using the basic techniques or methods

Now that you have completed a range of preliminary exercises involving an extensive experience of the brush, application and variations of the wash technique, and the management of colour gradation and tone, you will no doubt be wanting to paint pictures. Exercises involving the basic techniques will help you to determine your own style or approach. Experiment with the three basic methods indicated on p. 66. Take as a theme a simple landscape arrangement – say, some trees, rocks, hills, and sky – make three separate studies of this (a) in superimposed, transparent washes, (b) using the wet-in-wet technique, and (c) by the direct method. Compare the results, and study the effects you have obtained. Which study is the most successful or pleasing? Why? Did things go wrong anywhere? What parts could you improve? How? Repeat this exercise with different subject-matter. Decide which of the three approaches seems suited to you as an individual. But remember that you will probably need to be proficient at all three, and no doubt you will use them in combination as your skill and interest in watercolour painting develops.

Finally, your developed skill should enable you to achieve your primary intention of producing watercolours uniquely your own in concept and handling. Employ the general procedure outlined earlier in this chapter. And perhaps you should re-read the sections on The Importance of Seeing and The Five-Step Approach, which are located towards the end of Chapter One. In art, the basic principles remain the same regardless of the medium or means of expression. Now that you are painting, don't neglect your basic drawing skills, or underrate their importance.

Presentation of Watercolours

Successful watercolour paintings, especially those done in pure transparent colours or colours like gouache or tempera paints, are easily soiled or damaged and require protection from the atmosphere. A watercolour painting on a loose sheet should be glued under pressure to a backing board, set in a light-coloured or white board mount, and displayed behind glass in a narrow wooden moulding. You can attempt this task yourself if you feel competent, but generally it is much less trouble, and more likely to be done properly, if you leave it for the professional picture framer.

4
Oil Painting

Dating from the 15th century, oil painting historically is a more recent medium than water-colour painting. It is undoubtedly the most common form of painting today. But while there are one or two points of similarity between the two methods, in most respects oil painting is the opposite of watercolour. Nevertheless, it is an excellent medium for the beginner or student painter.

Traditionally, oil painting is a slower, more laborious procedure than watercolour, requiring more extensive and, generally, more expensive equipment. But its great advantage for the student is that, being slow drying, it allows a longer working time. And as the paint is thick and opaque, it permits any amount of over-painting so that corrections and alterations can be made at any time; mistakes can be covered over, or scraped or wiped off, and re-painted. Unless colours are diluted excessively, they cannot run, not even on a vertical surface, so there can be no accidental colour minglings or other unplanned happenings; nor can there be hard rims or edges to colour areas caused by fast drying, as in watercolour. Oil painting, unlike watercolour, usually requires an upright or vertical surface, and the painting should be done standing; physically it is not easy to do oil painting sitting down, for the way the materials are used and the need to step back some distance to check and evaluate progress necessitates freedom of action and movement. In watercolour, a white paper or surface on which to paint is virtually essential; a white painting surface in oil painting is undesirable, even a disadvantage. And although a pure white ground is prepared on the painting support, it normally is tinted or lightly coloured to receive the painting proper. Again in oil painting, although the method of painting will decide, it is traditional to brush in the darker colours first and to work up to the stronger colours and light areas last. Unlike pure watercolour, white pigment is added to lighten colours, and in oil painting the white of the ground is rarely used for this purpose. Both painting techniques show no apparent differences between the wet and dry colours (that is, the wet colours do not change their appearance on drying, as poster paints and cheap powder colours almost certainly will). But whereas watercolour paints entail little technical risk due to the pure permanent pigments and simple recipes used, oil paints with their oils and resins and more complicated chemistry are subject to varying degrees of uncertainty.

Oil painting today is characterised by a greater diversity of approach than at any time in its history. Some 200 years ago there existed probably only one technique or method, traditionally perpetuated in the great academies. Today, oil paint can be applied to almost any surface, in any sort of way, for a bewildering variety of artistic intentions. But for our purposes, we can reduce this apparent confusion of approach to three basic techniques, and as a student you need not concern yourself overmuch with other methods. The three we shall discuss, which you will probably use to some extent in combination, should meet all your painting needs at this stage.

Methods

Before you can begin the actual painting, two essential preliminary tasks have to be completed. Regardless of the method of painting, a support must be sealed and prepared to receive the painting. You might like to think of the support (80) as a backing of some kind,

80 The structure of an oil painting. 1—The support (canvas, cardboard, hardboard, etc.); 2—white ground (3 or 4 coats); 3—priming; 4—underpainting; 5—overpainting (one or several layers of paint, and varying in thickness).

and supports for oil painting at various times have included metal, wood, canvas, paper, cardboard, hardboards such as masonite, and even glass. The traditional support is canvas, which comes in varying grains or textures depending on the nature of the weave; thus, you can have a fine grain, a medium grain, or an open or coarse grain canvas (81). Normally, a board support was prepared by giving it several coats of a plaster and glue mixture called gesso. When this gesso had dried out hard, it was sandpapered smooth to a brilliant white finish, and tinted ready to receive the painting; an important function of this kind of ground was to supply an underlying luminosity to the superimposed paint layers. However, you need not go to this amount of trouble. Obtain several panels of masonite, plywood, heavy strawboard, or similar material of an appropriate size. Coat them two or three times in opposite directions with a good quality high-opacity, flat white undercoat, applied with a 2 or 3-inch brush, allowing each coat to dry, of course, before the next is added. When this surface is hard dry, give it a quick rub with sandpaper, and your panel is ready. While

81 Canvas textures (*actual size*). The three main textures. 1—fine grain; 2—medium grain; 3—open or coarse grain.

you have the paint out, you would be wise to prepare a number of panels, in a kind of assembly line technique; do 6 or 8 at a time, so that your painting activity is not interrupted.

Assuming you have made your preliminary studies and working drawings, the next stage is the blocking-in of your composition. Don't use charcoal or pastel or pencil, all of which are messy and may discolour the paint which follows. It is far better to make your blocking-in with a small flat bristle brush and thinned colour; choose a colour to suit your proposed painting and you can incorporate parts of this underlying linear arrangement in the finished treatment. Use a cloth to rub out as many of the wrong lines as you can. If possible allow this blocking-in to dry before you work over it, but again this will depend on your method of painting.

There are three basic methods or techniques of applying the paint to the prepared surface.

Glazing
Glazing is the technique of applying thin transparent layers of diluted colour one upon the other, or over dry opaque areas, to achieve a depth and brilliance of colour. Each glaze is allowed to dry before the next is added, and any number can be applied. It has been said that the great Venetian master, Titian, used 30 or more glazes in some of his paintings to obtain his characteristic richness of colour. Glazing, obviously, is a time consuming technique which must be done indoors, in a studio, and it may take months to complete a picture; therefore, it is advisable to work on several paintings simultaneously. While initially you probably will not use glazing to a great extent, it is a technique of considerable historical significance in the story of oil painting.

Wet-in-wet

Wet-in-wet (Plate 3) refers to a method where first an underpainting is made showing the separate colour areas and main forms, but without any detail. This can be applied lightly with diluted paint, or it can be 'scrubbed' onto the panel with a rather dry brush and un-thinned paint – either way, parts of this underpainting can be allowed to remain to show through the later painting. Next, the first distribution of light and dark areas, definition of forms, and an indication of light effects, are brushed in, still without much detail. Now the local colours of the subject-matter are introduced, all the colour areas being worked-up gradually, so that the painting grows consistently over its entire surface. The final applications of paint – the stronger colours, lights, and even high lights – now are applied 'wet-in-wet' on the existing paint layers, so that the completed painting, in fact, is finished in one period of activity – although you can add strengthening touches and definitive accents later, if necessary. This method produces a paint surface, consequently, that may consist of tiny areas of the tinted ground and fragments of the linear blocking-in and thin underpainting which show through, as well as the upper layers of paint in their varied thicknesses and textures (82).

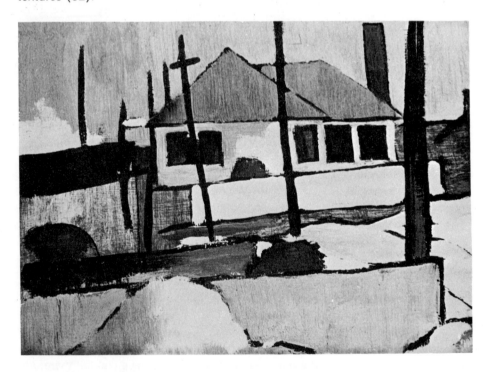

82 Oil painting, wet-in-wet, detail from **Plate 3,** '*Highbury Avenue*', (1952) by Max Dimmack.

Alla prima

Alla prima (Plate 4) implies a single application of paint without underpainting or super-imposed glazes, enabling the painting to be finished in the one painting session, directly from the subject, with white pigment being used to lighten colours (83). The alla prima technique is a comparatively recent development following the introduction of colours commercially produced in tubes, and it is the characteristic method of outdoor work and sketching in oils. When you are painting out-of-doors, alla prima, remember that colours mixed on a palette look somewhat darker when applied to the luminous white ground of the panel or canvas, so that when the painting is finished and taken indoors the colours often look rather dark and low-toned. To prevent this, you should slightly intensify the colours you use. Alla prima is the method in which the student learning to paint in oils is more likely to experience success and to gain confidence, and for this reason it holds an initial advantage

83 Oil painting, alla prima, detail from **Plate 4,** *'Still Life'*, (1966) by A. W. Harding.

over other techniques. But as soon as you acquire confidence and competence you should experience the other methods described. In fact, learn to use them all, so that you can combine them to produce more fully-realized and aesthetically satisfying paintings interpreting your subject-matter in your own way. This is the way that art is made.

Materials

The basic materials comprise the support and its ground, the paints, the medium, brushes, and various accessories such as an easel, palette, palette knife, dip cans, and the like.

Supports for oil painting, and a simple method of preparing a ground, have already been described on p. 82., so there is no need to discuss them here.

The paints

The paints used for oil painting, like watercolours, are made from high quality, finely-ground pigments, mixed with an oil, and left to mature before the finished colours are filled into metal tubes of various sizes (84). The oil used usually is linseed oil, although other oils

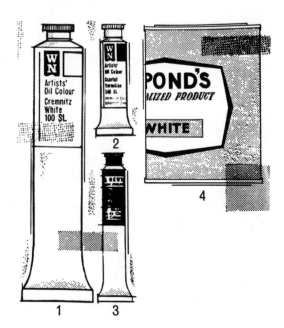

84 Oil colours (*half size*). 1—large tube, 1 lb, artists colours; 2—small tube, artists colours; 3—small tube, students colours; 4—artists quality colour in half-pint tin.

such as poppy oil and walnut oil have been used. Each colour is prepared individually to its own recipe, and each possesses its own particular characteristics and working properties. The best quality oil paints, of course, are made for the professional artist, and these can be very expensive. A secondary range of Student's Oil Colours (84:3) is made and, while these

are cheaper, their working qualities, colour brilliance and consistency are quite satisfactory for our purposes. So, while you regard yourself as a student painter, always buy Student's Quality paints. The choice of colours, as in watercolour, is a personal matter, but the following colours – not that you necessarily need them all – should prove an adequate range with which to start:

Flake White, Burnt Sienna, Chrome Yellow, Raw Umber, Naples Yellow, Sap Green, Yellow Ochre, Chrome Green, Cadmium Yellow Middle, Cerulean Blue, Chrome Orange or Cadmium Orange, Cobalt Blue, Light Red, Prussian Blue, Indian Red, Rose Madder, Cadmium Red or Vermillion, Magenta or Cobalt Violet, Alizarin Crimson, Ivory Black or Lamp Black.

Remember that different manufacturers may market colours under varying names, which is sometimes confusing. To keep your colours in good condition, keep the tops always on the tubes, and store your tubes in a box or tin (85). Because you will use more white in mixing,

85 Student's oil painting set showing brushes, palette knife tubes of paint, linseed oil, turpentine, and palette in lid.

buy your flake white or permanent white in 1 lb. tubes (84:1); generally, the larger the quantity you can buy the paint in, the cheaper it is likely to be. Artists oil colours of acceptable quality are now available in $\frac{1}{2}$ pint tins (84:4) and, if you intend to do a lot of oil painting, this is probably the most economic way to purchase your paints – so long as you keep the lids on the tins all the time to prevent the paint from drying out.

The medium

A medium is necessary to thin the paint to a working consistency. As it comes from the tube, oil paint is a thick paste, and while it can be applied in this form, it is usual to mix some form of medium with the tube colour. This enables you to apply your oil paint in a variety of ways ranging from thin, transparent glazes of paint heavily diluted with a thinning medium to

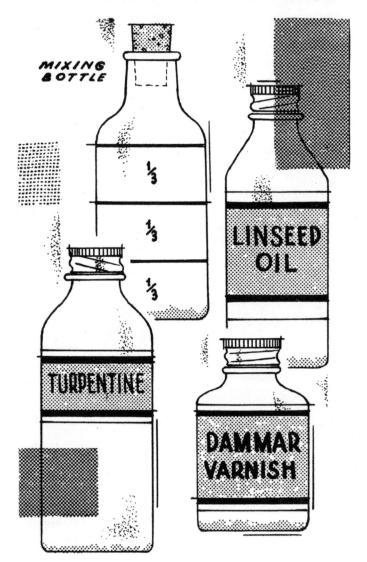

86 Medium for oil painting, the three fluids and the mixing bottle.

thick strokes and piled-up paint (called impasto) applied directly from the tube. The most common thinner is a good quality turpentine, although lighter fluid and petrol are equally as good. Excessive thinning with turpentine alone deprives oil colour of its semi-gloss, and many painters employ a medium of their own to overcome this. You can easily make an excellent, time-tested medium (86) by mixing 1/3 linseed oil, 1/3 turpentine, and 1/3 dammar varnish. These three fluids respectively transport and bind the pigment, thin the colour, and maintain the gloss. Take a narrow-necked, corked bottle of reasonable size, paint lines on it to show three equal measures or quantities, and use it as a mixing bottle. You will have to purchase your dammar from an art supply store, but, to cut expenses while you are a student, buy good quality linseed oil and turpentine from your local hardware store. Get refined linseed oil if you can.

Brushes

Brushes (87) for oil painting can be expensive and, as with all forms of painting, there is no substitute for a good brush. They are made from hog bristle, come in various sizes from No 1 (small) to No 12 (large), and three shapes – flat, round, or filbert, which is flat but with a curved end. The three shapes each allow certain manipulations or painting actions. Use your flat brush for laying-in or daubing oblong areas or flat patches of colour, your round for 'drawing' with paint when you are clarifying forms and defining detail; and the filbert for broad covering strokes and scumbling or dragging the paint across the surface. You will require a number of brushes, at least 6 or 8, and you should include flats and rounds. Sizes of brushes will depend on the size of your painting, of course, but it is sound practice to use as large a brush as possible, so you should have a range of the larger sizes. For smaller touches or fine lines and details, you can use a good quality sable brush.

Oil painting brushes should always be cleaned thoroughly after use. Soak them first in turpentine or lighter fluid to remove the paint, and then wash each brush separately with warm water and soap, rubbing the brush on the soap and then working it backwards and forwards on the palm of your hand to lather it. When clean, rinse it in clean water, shape the bristles, and store the brush to dry. References to the ill-treatment of watercolour brushes (see p.61) apply equally well to your oil painting brushes. A good bristle brush will wear down with use, but it should retain its shape and give reliable service over a long period if it has been properly cared for.

The palette

A palette (88:5) is a necessary surface on which to mix your oil colours when you squeeze them from the tubes. Palettes can be purchased, but this is not necessary. A rectangular piece of plate glass or masonite is all that you require. Always squeeze out your colours along an edge of the palette, to a definite order, say from light colours through to dark. Don't put out colours that you know you are not going to use. Scrape down and clean your palette regularly and develop the habit of working from a clean palette – a dirty palette messed up with accumulations of old paint is hardly likely to lead to clean colours, or to inspired painting!

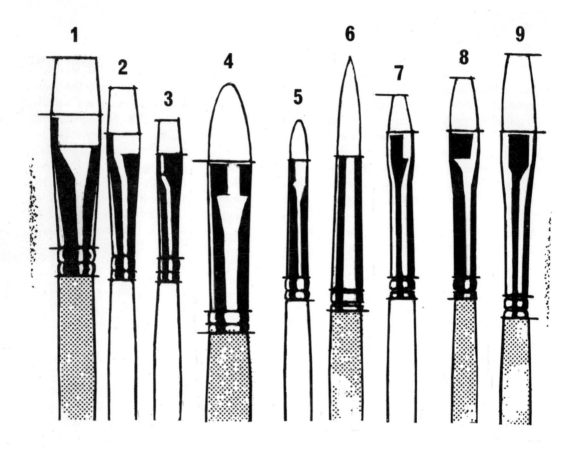

87 Oil painting brushes *(actual sizes)*. 1,2,3 long handled hog bristle brushes, flat (sizes 8, 6 and 4); 4,5—long handled hog bristle brushes, filbert shape; (sizes 8 and 4), 6—long handled hog bristle brush, round (size 6); 7,8,9—long handled hog bristle brushes, flat, showing different bristle lengths.

88 Oil painting accessories. 1—palette knives; 2—painting knives; 3—single tin dipper; 4—double tin dipper; 5—wooden palettes.

Dip cans

Dippers or dip cans (88:3, 4) are small metal containers which clip on to the palette to hold a supply of turpentine, or prepared medium, or both. Again they are not essential, but you will find them very useful. The use of a double dip can enables you to have always available both a supply of thinners or turpentine, and a supply of medium. If you cut large corks to fit the openings of the dippers, you can cork them when not in use; this saves you the trouble of tipping the excess fluids back into their storage bottles. But you can just as easily use small screw-top jars instead of purchased dippers.

Palette knives, painting knives

Palette knives (88:1) and painting knives (88:2) are used for mixing the colours on the palette, for applying oil colour thickly in an impasto, or for scraping off unwanted colour. They can be purchased in various shapes and sizes, but you will find in practice that any blunt, flexible knife will meet your needs, At times, the knife is useful when you want thick and generous applications of paint, and strong textures result from the trowel-like manner in which it is used.

An easel

An easel of some kind to support your panel and to hold it rigidly at a comfortable working height is a useful accessory. If you become interested in oil painting, you should try to obtain one — or to make one. They come in a variety of designs and sizes, but the common chalk-board type easel with adjustable pegs will satisfy our student needs. As you progress in your painting, you can think about more complicated kinds of easels. You can then acquire a better one later, if you need it.

In addition to the materials and items of equipment indicated, you will need screw-top glass jars and bottles in which to store liquids, plenty of clean rags and newspaper, and protective clothing such as a smock, old shirt, or even a dust coat, so that you can work freely and securely, without fear of damage to clothing or surroundings.

Subject-Matter

Oil painting is a particularly versatile medium with a wide range of surface applications. It can be used for representational painting regardless of purpose, and with almost any kind of subject-matter — landscape, still-life, the human form, portraits, or imaginative compositions. It is equally satisfactory for an abstract treatment of subject-matter, and for the non-objective and geometric approaches which characterise much of today's art.

Recent Developments

While oil painting in recent times has disintegrated from a single accepted style into a diversity of approaches and purposes, there have occurred few technical innovations of any significance. An oil-based colour is still the paint most widely employed. We have witnessed

attempts to use other materials in conjunction with painting, such as the collage innovations of Picasso, Braque, and the early Cubists who actually glued additional materials like paper or fabrics to the canvas, or the later Dada artists who incorporated actual objects or pieces of objects. But these activities were more experimental phases and shock tactics, and essentially transient in nature, even though you can still see them being used today.

Perhaps the most important stylistic tendency of modern painting has been an interest in, and exploration of, the aesthetic possibilities and visual interest of texture and surface manipulation resulting from thick paint applications, not necessarily brushed on, but splashed, poured, dribbled, thrown, and so on, using a variety of implements, as in 'action' painting and much abstract expressionism.

Modern technology has introduced new kinds of paint – P.V.A., acrylic, various emulsions and enamelised paints – but student painters need not concern themselves with these, most of which have yet to stand the most searching and final test of all, the test of time. Learn to paint well in oils first. Explore fully the almost unlimited possibilities of this medium for picture making. When you have acquired proficiency in the basic techniques and skills of painting, then – and probably only then – should you become concerned with the peculiar characteristics and possibilities of other kinds of paint.

Characteristics of Oil Painting

At the beginning of this chapter, you read that oil painting, in most respects, is the opposite of watercolour. If you compare a 'finished' oil painting (rather than a quick outdoor sketch or alla prima impression) with a traditional transparent watercolour, the truth of this statement becomes abundantly clear.

Oil painting, because of its more complex nature and laboured technique in opaque colours, lacks the surface spontaneity and delicacy of the pure watercolour, yet it can show unparalleled depths, luminosity, brilliance and richness of colours. It permits the most subtle gradations of tone and the most skilful gradations of light, so that extreme accuracy of representation and expression of minute detail becomes possible to an extent not attainable in the more suggestive watercolour medium. The thick responsive paint allows an infinite variety of textural effects – even to a kind of low or relief modelling, as in the trunks of cypress trees in paintings by Van Gogh – so that painted surfaces can show considerable animation and interest. The problems associated with a normally uncontrollable drying rate and a flowing medium place limitations on the size of watercolour paintings; large watercolours generally are rare. The nature of the oil techniques, on the other hand, and its longer working time, eliminate this difficulty, and oil paintings theoretically can be of any size. Consequently, a large oil painting of artistic merit assumes an impressive grandeur and dignity rarely possessed by an equally excellent but smaller and slighter watercolour.

Completed oil paintings, under normal conditions, are displayed unmounted and without glass in substantial wooden frames, which are available in a variety of mouldings ranging from plain to ornate and heavily decorated.

Useful Exercises

As with any art technique, it is good policy to find out the possibilities and limitations of the medium before you get down to the serious matter of producing your own paintings.

Exploratory exercises
Introductory exercises, somewhat similar to those indicated for watercolour, help you to get to know your materials – the possibilities of your brushes, how to use them, the characteristics of oil paint, the mixing of colours, and so on. If you are using oil painting materials for the first time, engage in such a series of experimental experiences; don't rush into the business of producing pictures until you have acquired adequate knowledge of what is involved.

Exercises in paint application
Plan a series of small exercises in paint application. Try various ways of applying the paint to the painting surface, from paint heavily diluted and almost transparent to paint that is thick and opaque, straight from the tube. Try flat layers of paint and thick impasto (89). Try laying in broad areas (90) of paint with large round or flat brushes; then try thin lines with a small flat brush used on edge. Use a palette knife or a painting knife to apply and spread the paint. Compare this treatment with the effects obtained with brushes.

Exercises in colour harmony
Try exercises in colour. Experiment with small abstract, area-filling exercises in rectangular panels (90). Use pure colours, mixed colours, warm colours, cool colours. Try working in a restricted range to achieve a colour harmony – say, the three primary colours and black, or autumn colours, or winter colours. Try combinations of warm and cool colours, such as one warm colour and three cool colours. Try other variations, Consider always the colour harmony; think about the nature of the colours themselves, how they relate to each other, and how visually pleasing they appear in combination.

Exercises in texture
Exercises involving a consideration of texture (91) should not only prove useful in themselves, but should also teach you a great deal about the use of your brushes. In small rectangular patches of paint, using different brushes and a wide variety of strokes or touches, see how many actual or real textures you can create, from glossy smooth to thickly rough. Now try to simulate or represent the textures or surface qualities of common and familiar materials; in small panels, try to suggest velvet, chenille, folds in a drape, curly hair, the surface of a rock, weathered timber, polished wood, galvanised iron roofing, the bark of a tree, a paling fence, a gravel path, a cane basket, a mass of foliage, swirling water, and other textures. Concern yourself only with the textures; don't draw the objects themselves. The ability to suggest or to convey textural qualities is an important painting skill and one that you should practise constantly. If you study paintings by famous artists you will see how superbly well textures can be suggested.

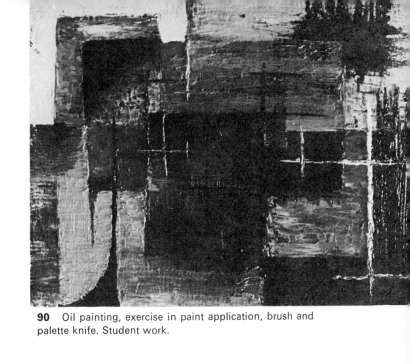

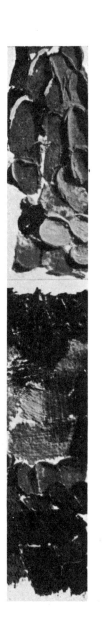

90 Oil painting, exercise in paint application, brush and palette knife. Student work.

91 Oil painting, exercise in texture, still life theme. Student work.

89 Oil painting, exercise in paint application, impasto.

Exercises in tone

Now try exercises in tone (92). Take simple everyday objects as indicated for watercolour, or set up a simple still-life arrangement. Paint it first as a monochrome, in a single colour, using the full range of attainable tones from dark to light. Discover the use of black and white to achieve and control tone. Apply what you have learned to a further study of your still-life group, this time in the natural colours and full tonal range. Analyse carefully what you see to judge tonal changes; aim to reproduce these tonal subtleties in your study. Now try it a third time in flat areas of intensified colour related tonally. Notice, for instance, that cool colours (greys, grey/greens, grey/blues, subdued browns, and the like) appear to recede

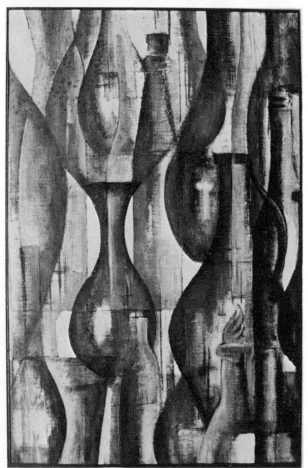

92 Oil painting, exercise in tone, still life theme. Student work.

or move back while the warm colours (reds, yellows, orange, tan, red/browns, yellow/
greens, etc.,) appear to advance or come forward. Obviously, the control of tonal values in
painting is most important, as a study of the works of any of the masters will quickly show;
a careless or incorrect use of tone can have a disintegrating effect on both the colours used
and the subject-matter represented.

Exercises in the basic techniques

Experiment with superimposed glazes, wet-in-wet, and alla prima methods. Again, use a
simple still-life arrangement (93). Make separate studies using each of the three approaches

93 Oil painting, exercise in technique,
wet-in-wet. Student work.

94 Oil painting, alla prima, *'Drums over Africa'*. Student work.

and incorporating where appropriate all that you have learned so far about the use of brushes, paint application, colour, tone, texture, etc. Use additional still-life groups or even landscape subjects to gain further experience in these basic techniques. Learn to use them in combination, according to the nature of your subject-matter and your interpretation of it.

Exercises in adaptation

Try exercises in adaptation. Take a print or reproduction of a landscape subject. Re-design it. Change the format, alter the colour scheme, develop a new centre of interest, introduce a different mood or feeling, using all or part of the original print. But transform it, to create a new statement of your own, a creative adaptation. You can repeat this exercise any number of times. And it is a most instructive exercise for it can teach you a great deal about the making or structuring of pictures.

Exercises in composition

Finally, you might like to try some artistic 'problem-solving', involving exercises in composition and picture-making and incorporating the complete process from preliminary sketches and working studies to the planned composition to the completed, considered statement in paint. These exercises can range over a variety of subject-matter – landscapes, street scenes, still-life groups, abstracts – as the following examples show:

1. vertical composition in a vertical panel – landscape;
2. vertical composition in a horizontal panel – landscape;
3. horizontal composition in a vertical panel – landscape;
4. horizontal composition in a horizontal panel – landscape;
5. composition in two dimensions, in monochrome – still life;
6. composition in three dimensions, in monochrome – still life;
7. composition in two dimensions, in high tones – buildings;
8. composition in three dimensions, in low tones – buildings;
9. composition of intersecting horizontal and vertical forms to produce a 'static' effect – non-objective;
10. composition of curvilinear forms to produce a rhythmic effect of movement or 'flow' – non-objective.

These examples, it must be emphasized, are not intended to comprise a comprehensive or systematic set of exercises. They are included simply to demonstrate the useful problem-solving type of exercises which can be devised – and which you can easily devise yourself – to compel you to think about the making of pictures and art generally, to strengthen your technique, and to help you to produce soundly-structured creative interpretations rather than impersonal, imitative representations of the subject-matter.

Exercises like the ones indicated should form an essential part of any planned program in painting. However, most students seem to want to produce finished paintings almost immediately. But, as in most things, you must learn 'to crawl before you can walk' if you want to make real progress. In painting, you must expect to learn and to master the basic skills, techniques, procedures and attitudes before you can hope to use these to meet your own expressive needs. If you omit or neglect these formative exercises, it is doubtful whether you will ever produce paintings of merit. But if you engage in such exercises conscientiously and successfully, and apply what you learn, there is a good chance that you might create worth-while paintings.

There is a final point to remember. The related and basic activity of drawing in a variety of materials, and the application wherever appropriate of the five-step approach outlined in Chapter One, should continue as integral parts of your painting program, re-inforcing, supplementing and expanding the progressive development of the concepts, attitudes and skills essential to successful painting.

5

Linoleum Cutting and Printing

The cutting of a design or picture into the surface of a piece of linoleum (95) which is then inked so that a print (96) can be taken is a common and popular art activity. If you have never tried this technique, you will find it not only an absorbing and challenging process which can be successfully accomplished with inexpensive materials and equipment, but one which offers you several possibilities for individual creative action.

Materials

The essential materials you will need include, of course, the linoleum itself, the cutting tools, ink, paper, and some means of applying pressure. Try to obtain a soft linoleum, preferably light in colour; soft brown 'battleship' linoleum can be purchased in squares from art supply stores, or sometimes you can obtain it as off-cuts from shop-fitters who use it as a floor covering, especially in offices, schools, and corridors. If you can't obtain this kind of linoleum, any soft smooth, undamaged lino will do, but avoid lino which has become brittle through age or excessive waxing. Then you will need a range of simple cutting tools (97); specially designed sets of cutters or gouges which fit a common handle can be purchased, and these can be supplemented by improvised tools such as a sharpened pocket knife, large needles, a trimming knife, safe razor blades, and by home-made implements such as sharpened nails or umbrella ribs set in make-shift handles. A variety of suitable papers, thick and thin, smooth and slightly textured, white and coloured, such as typing and duplicating paper, newsprint, litho paper, cover paper, cartridge paper, selected wrapping papers, etc., cut to a size somewhat larger than the block you wish to make, should be available so that you can experiment with a range of printing effects. A thicker paper tends to be tough and more durable, but a thinner paper is likely to take the ink better. There are two main kinds of ink available. The traditional oil-based ink, such as printers ink or student quality oil paint, can be used on undampened paper, but is slow-drying and possesses the additional disadvantage of creating considerable cleaning difficulties. The more recent water-soluble printing ink (such as Japanaqua), which gives a perfectly satisfactory result on dampened or dry paper, reduces the cleaning-up process to a minimum – and if you are doing your lino printing at school, this is an important consideration. As the actual printing is done under pressure, naturally some means of applying pressure must be provided, and this can range from your hand or fist to the back of a large spoon to a clean roller to a book press (102) or etching press. In addition, your equipment should include several pieces of $\frac{1}{4}$ inch plate glass or smooth masonite, size 12 inches by 10 inches, on which to roll out the ink; rubber rollers, 6 inches to 10 inches in width; a pliable knife to spread the ink on the plate; cleaning materials (mineral turpentine or kerosene and clean rags if you are using oil-based ink); newspapers to cover

95 Linoleum block print, the block. Student work.

96 Linoleum block print, the print taken from the block shown in **95.**

the working area and to protect furniture. Finally, so that you can proceed logically and successfully, it is standard practice to prepare a preliminary design, and for this brushes, Indian ink and scrap drawing paper are likely to be needed.

Set out like this, it seems that an extensive 'kit' is necessary. But this is not so. There are other art activities which require just as much, or more; and in any case much of your lino printing equipment can be used in other printing processes, as we shall see in the next chapter. So don't allow the nature of the materials to discourage you from participating in a thoroughly rewarding creative experience.

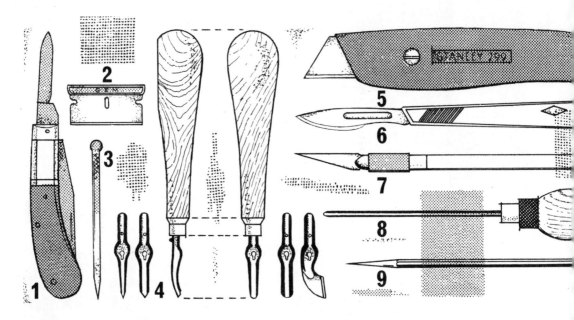

97 Linoleum cutting tools. 1 —sharp pocket knife; 2—safe, one-sided razor blade; 3—sharpened nail; 4—purchased cutters or gouges and common handle; 5—Stanley trimming knife; 6—Gillette cutter; 7—Exacto craft knife; 8—sharpened umbrella rib set in bootmakers handle; 9—large needle made from discarded dental probe.

The Design

Because the appearance and effectiveness of the print is largely determined by the distribution of light and dark areas and the contrasts these afford, it is sound procedure to commence by preparing a working design (98) so that you can visualize the end-product and clarify details of subject-matter and composition. As indicated, brush and ink can be used, or you might prefer black crayon or cut and torn pieces of black paper pasted on a white backing sheet; the latter permits easy manipulation of different arrangements of shapes,

98 Design for lino-cut, ink on white paper, showing distribution of light and dark areas. Student work.

99 Linoleum block print, based on design in 98. Student work.

and is particularly appropriate when you are creating an abstract or geometric design. On the other hand, if you prefer to cut directly into the lino without any preliminary planning, allowing the design to evolve as a result of the actual cutting process, then by all means do so. In preparing your working drawing, aim for a simple flat, two-dimensional treatment relying on the combination and placement of dark and light areas and textural effects for interest and variety. Include both a linear treatment as well as areas or masses of black and white. Because of the nature of the cutting process, realism and natural appearances are difficult to achieve, and undesirable; therefore you should simplify the details and subject-matter of your design, adapting them to the requirements of the technique. Before you proceed to cut into the linoleum, you would be wise to check your design to see if it is a pleasing composition, showing a balanced distribution of masses and effective contrasts.

Transferring the Design

There will be occasions when you will need to transfer your design to the surface of the lino. You can accomplish this in one of several ways. It can be drawn on directly with pencil, of course, but this is difficult to see initially and much more difficult to follow during the cutting process when it becomes smudged. Another way is to cover the surface of the linoleum with opaque black paint to receive a tracing of the prepared design (101:1). If you make your design on transparent tracing paper, the top side of the design can be rubbed over with white pastel or chalk, the paper turned over, and the outlines then traced through as white lines on the black surface, but in reverse, so that when the print is taken the original design re-appears, right way up. An alternative method is to whiten the surface of the linoleum with poster paint, place the pencilled design face downwards on the white surface, and trace through, so that the design in reverse appears as pencilled lines on a white ground. Finally, you can use ordinary carbon paper under your design and simply go over it with a hard pencil (101:2). In all cases, to avoid the possibility of mistakes and false cuts, you would be wise to indicate clearly the black and the white areas — or the areas to be left and the areas to be cut — by using some simple system of shading or marking (98), or by using the symbols 'b' and 'w'. These simple precautions are important, for once a piece of lino is removed in error, there is no possible chance of replacing it.

Cutting

When your design has been transferred satisfactorily to the linoleum block, you can commence the cutting process. Theoretically, any mark or line incised in the linoleum, by any tool, should register in the print. All cutting tools should be sharp, and kept sharp during the cutting process; one or two small files and an oil stone are handy aids to have nearby. Before cutting the block proper, you might like a short experimental period of cutting on a strip of scrap lino (100), to make sure all tools are sharp and to explore their possibilities. If you are unfamiliar with lino cutting as an activity, this is an essential preliminary exercise. The cutting should be done with firm deliberate strokes, not too deep (101:3), taking out each piece of lino cleanly (101:4). Refer constantly to your prepared design, and keep your mind on the cutting, so that you cut away only unwanted parts, leaving raised those parts of your design

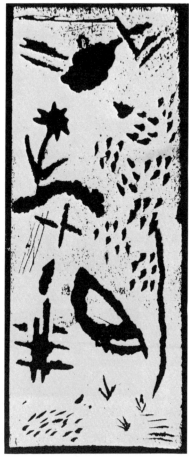

100 Experimental cutting strip and print, white ink on black paper. Student work.

which are to receive the ink, thus producing the characteristic 'black-on-white' result. Background areas, having been cut away, do not print. In cutting and cleaning away background areas, attractive textural interest can be achieved by leaving small pieces and fragments of surface which will take ink and print, adding surface richness and liveliness to the final product; if such effects prove excessive or distracting, you can easily reduce or remove them by further cutting. The disadvantage of undercutting (101:5), which leaves edges of areas without adequate support and leads to imperfect results, must be realized; all cuts should be V-shaped on section (101:5) to support fully the printing surface. You should also avoid cutting the lino too deeply; deep cutting, which may expose the hessian backing, weakens the block and destroys its rigidity. When this happens, you might have to glue your lino to a wooden base to prevent cracking and other damage. When you think you have finished the cutting, check your lino cut against your prepared working design; make any small adjustments or refinements that you feel are needed.

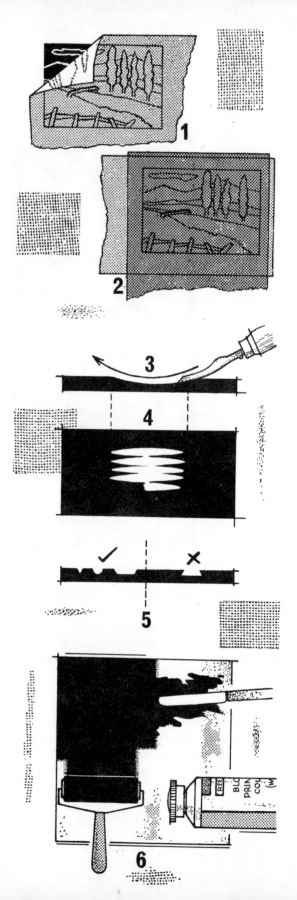

101 Making a linoleum block. 1—transferring the design using chalked tracing paper over blackened lino surface; 2—transferring the design using carbon paper under a design drawn on tracing paper; 3—the cutting stroke; 4—appearance of clean cuts; 5—good and bad cutting technique; 6—distributing ink on plate and inking the roller.

Inking and Printing

Your block is now ready for inking and printing. Squeeze a small quantity of ink onto the plate glass or smooth masonite, spread it evenly with a knife (101:6), and run a roller vigorously backwards and forwards so that it is inked thoroughly (101:6). Now roll this inked roller several times in opposite directions across your linoleum block so that all uncut, standing portions of the surface are inked. At this stage, you should take a proof print. Place a piece of paper larger than your block carefully on the inked line, cover it with several thin backing sheets, and apply an even over-all pressure using a clean roller or a book press (102:1). Then lift the top papers gently and check the quality and clarity of the printing before you remove the print (102:5). The proof print you now have obtained can be examined to consider the distribution of light and dark areas, the definition of subject-matter, textural effects, or to decide whether further cutting is necessary. If further cutting is needed, clean the block and continue cutting in the normal way. If, however, you are satisfied with

102 Taking a linoleum print. 1—book press; 2—method of holding spoon to exert pressure; 3—large wooden spoon; 4—clean roller; 5—checking the quality of the print; 6—achieving accurate colour registration by the use of triangles.

the print as produced, re-ink the block. Try several impressions on papers of different types and colours so that you explore a range of effects. Consider these. Then you can make a selection, and proceed with the final printing. The block, of course, should be re-inked each time you print if you want maximum effect and contrast. If you want to use heavier papers such as cartridge paper or cover paper it is sometimes advisable to dampen these before you print so that they become partly absorbent and receive the ink more easily, thus giving a clean, precise registration. Papers with an obvious grain or texture might also require dampening. While several ways of applying pressure to the block have been indicated, the smooth back of a large dessert spoon or wooden mixing spoon (102:3) is the simplest, yet it enables you to achieve variety of treatment by varying the pressure. To apply an even pressure, hold the spoon near the bowl, with two fingers pressing in the bowl (102:2), and use it in close circular, motions over the whole surface of the paper, meanwhile holding the paper with your free hand to prevent accidental movement. By varying the pressure as desired, you can produce gradations of tone, develop a centre of interest, or experiment with special or unusual effects. See what you can do. The more you experiment, and the more individually you work and direct your own efforts, the more you will learn.

103 Linoleum block print. Student work.

Cleaning-up

When you have finished printing, the block, rollers, inked plates, even the knife, must be cleaned thoroughly. If you have used a water-soluble ink, all your equipment can be washed under a tap immediately after use, and allowed to dry. If you have used an oil-based ink,

all inked surfaces should be cleaned as much as possible first with crumpled newspaper, then with cloths dampened in kerosene or mineral turpentine, and finally washed in warm soapy water. Proof prints, soiled paper, dirtied newspaper, etc., should be discarded continuously during the printing operations to maintain a clean area and reasonable working conditions. Tidy work habits minimize mess and contribute to a more satisfying experience. Don't try to work in conditions of disorder and endless mess.

Mounting the Print

No doubt you will want to display some of your successful prints, and these show to best advantage when they are mounted in off-white or light-coloured mounts. In size, the top and sides of the mount should be between 2 or 3 inches larger than the print, and the bottom larger again. An aperture or 'window' slightly larger than the print is then cut in the mount,

104 Linoleum block print, *'Pont du Cheval, Bruges',* (1935) by Malcolm Helsby. In the possession of Max Dimmack.

and the print fixed in position at the back by cellulose tape. If you use a piece of mount paper twice as wide as necessary, you can fold it like a book cover to protect the print more adequately. You might like to add two or three pencil lines bordering the aperture to give a finished appearance to the mount.

Additional Activities

So far we have been discussing printing in black — or in a single colour at least — but there are ways of introducing more complex colour effects which you might like to explore.

Two, or even three, coloured inks can be blended in bands or broad stripes on the plate glass, and the roller used in such a way that the separate colours are picked up. Choose or mix colours appropriate to the subject. You can then apply these to the surface of your lino block to introduce a limited colour interest to the resultant print (105). Alternatively, using

105 Linoleum block print, colours applied to block to give a coloured print. Student work.

two or three well-chosen colours as indicated, you can roll off a number of coloured backgrounds; let them dry, then print your design in the usual way, superimposing it on the coloured ground. Often charming and unusual effects can be obtained in this way.

If you want to produce only a small number of prints on coloured grounds, there is another variation you might like to try. Take several areas and shapes of coloured paper (cut or torn from poster paper and surface squares) and paste them without wrinkles on a backing sheet, either at random or in relation to the subject-matter of your design. A number of such backing sheets can be prepared if you like. By printing over this background arrangement, you can increase interest and introduce varied colour effects without a change of ink. These background shapes, however, must be in harmony with the general effect of the design you have cut in the lino; otherwise they can prove distracting and might spoil the impact of the print.

Finally, linoleum block prints can be produced in full colour (Plate 5) by the use of a number of blocks successively over-printed in separate colours, to give exceedingly rich or subtle colour effects and combinations. You will require a separate lino block for each basic colour, but if you keep the principles of colour mixing in mind, the number of blocks can be kept to a minimum. Thus, to achieve blue, yellow and green areas, you will need two blocks – one for blue and green areas, one for yellow and green, the actual green areas themselves resulting from the mingling of blue and yellow where they are superimposed. Therefore, to complete a print in full colour, up to 5 or 6 separate blocks may be required. These must relate with extreme accuracy, and precise colour registration is essential. A common practice is to cut around two or three small triangles, top and bottom, in the border of lino surrounding the block (102:6). Prints of these small triangles, in any colour, are taken on all the sheets of paper on which the final colour print will be made. The resultant triangular inked patches or areas are carefully cut out, and by fitting the triangular apertures or cuts in the paper over the triangles left raised on the surface of the linoleum, each sheet of paper is locked in position and accurate colour registration can be achieved. The production of a print in full colour, satisfying and rewarding as it is, involves considerable effort and time and therefore you should plan carefully. You might make a full colour working drawing or design, from which tracings of the separate colour distributions can be taken in order to produce the required blocks. Each block has to be cut, checked, inked, and printed in the usual way, and a complete 'run' with each basic colour is completed before the next colour is commenced. This means that you will need space to spread the wet prints as they emerge, colour on colour. Needless to say, the production of a full colour print is an absorbing artistic experience which will give you a deep sense of achievement. It is a truly creative activity.

Try one sometime!

6

Other Simple Printing Processes

If we consider linoleum block printing as a kind of basic printing activity, then there are a number of similar or related activities which can form part of your art program. Many of the skills and materials of lino cutting are used in these additional processes, and all possess the common characteristic of producing a print as the end-product. If you have already produced a linoleum block print, we can assume that you know something of the technique of hand printing generally. The activities which follow, then, need not be discussed as fully as the linoleum printing process in Chapter 5 because certain information, such as kinds of paper or the mounting of a print or cleaning-up, is common to all. But if you like to think of linoleum block printing as a basic printing process, then you can plan a whole area of personal expression around simple hand printing.

Block and Card Prints

Instead of cutting into a surface in order to produce an incised design, as you did with linoleum, it is possible to fix surfaces to a base and to print from these raised areas. Block and Card Printing (106), then, become simple adaptations of the linoleum block printing method. The technique and materials are virtually identical, but the nature of the block is different because lino is not used.

The first task, therefore, is to construct the block. Find a piece of flat board, plywood, masonite, or heavy strawboard and cut it to a convenient size and shape, usually a rectangle. This forms the backing to the block. On this you now glue a planned arrangement of materials of even height, but of different shapes and sizes, such as several pieces of card cut into abstract shapes and strips (106:1), with one or two pieces of textured card by way of contrast. Aim for a pleasing, balanced composition. If you use a quick-drying adhesive, such as hobby cement, you can prepare your block quite quickly (106:2). When the adhesive has set, the block can be inked (106:3) as you would ink a linoleum block and a print taken in precisely the same way (106:4). A simple variation is to make a block from corrugated card. Without cutting right through, remove areas of the surface. You can now insert different materials in the resultant spaces, or you can replace different shaped pieces of the card with the corrugations running in a different direction. Ink as indicated, and gently take a print from the new arrangement.

106 Making a card print. 1—cutting the component pieces from card or straw-board; 2—the pieces arranged and glued to a backing board of plywood, straw-board, etc; 3—inking the block; 4—taking the print.

If only card is used to build up an arrangement of raised surfaces, the resultant print is called a card print. But a variety of other materials can be glued down, such as flat card, corrugated or textured board, coarse sandpaper, thick string or twine, or small sticks like matches or ice-cream sticks, to form a pleasing pattern or arrangement with a diversity of shapes and textural characteristics. When this is inked and a print taken, the product generally is referred to as a block print.

The block printing process can be extended to print designs on fabrics, the inked block being printed downwards under pressure (generally by pressing with both hands or hammering with a fist) in a regular repeat on the surface of the fabric, which should be stretched across the surface of a table or bench preferably padded with newspaper so that a sharp registration is obtained. You can print your own designs on tea towels, table mats, small curtains, and similar articles, if you use a washaable fabric-printing ink.

Block printing offers you a challenge to experiment, to try different materials and textures. Explore all kinds of possibilities – you will be surprised, and delighted, with the artistically interesting effects and results you can obtain.

Glue and Sand Prints

The technique here (107) is closely related to the Card Print. First, make a rectangular block of strawboard or thick card of a convenient size; even thick paper will do. You will now need one of those glue tubes with a pointed nozzle. Use this like a pencil or crayon, and draw in glue directly on the card block (107:1). Immediately you have finished this 'drawing', and before the glue dries, sprinkle sand over the block so that quantities of sand are held in the glue, building up an arrangement of small ridges of sand (107:2). Allow ample time for the glue to dry out thoroughly, then tip off the surplus sand (which you should keep for future use). Now ink a roller, run it across the surface of the block so that the sandy ridges are inked (107:3), and take a print in the usual way (107:4). The print you get, essentially linear in appearance, should show a delightful range of textural variations and tonings. Sand is a common material and generally is readily available, but you can also use saw-dust, glitter used for Christmas decorations, and similar materials as additives in the glue.

If your subject-matter is representational or figurative in nature, it is an advantage to draw this in pencil first on the block and then to go over it with the glue. But sometimes you can achieve fascinating and unusual abstract effects by using the glue directly in a random fashion, and exploiting to the full the textural possibilities which result when the sand is added. Try combinations of additives, such as sand and glitter, or saw-dust and sand.

Monoprints

The production of monoprints is a simple and stimulating technique demanding spontaneous work and an individual response, and permitting several variations (108).

107 Making a glue and sand print. 1—applying the glue or hobby cement to make a drawing or design; 2—adding the sand, using an envelope to control the rate of flow; 3—inking the sand pattern; 4—taking the print.

1

2

3

108 Making a monoprint. 1—applying pressure to paper placed over drawing made on inked plate to obtain an impression of the drawing; 2—making a drawing on paper placed on an inked plate; 3—making a drawing or painting in full colour on a plate, and taking a print of this.

A smooth working surface which can be inked is needed; plate glass is best, but smooth masonite, linoleum, laminex, or even flat sheet metal can be used. Squeeze out a quantity of ink or thick paint, and roll it vigorously to secure an even distribution over the plate. More than one colour can be used to obtain a blending, if you like. Now draw directly on this inked surface, using your finger or any pointed implement, such as the top of a ball-point pen, a pencil, the edge of a piece of cardboard, a sharpened stick, a nail, or other simple improvisations (108:1). This drawing should be simple in appearance and boldly executed. The lines you make on the inked surface displace the ink to expose the surface of the plate, so that areas exposed, having no ink, do not print. The inked background areas, however, will register an impression on the printing paper.

Gently place a sheet of paper over the inked surface and press it lightly with your finger-tips so that it adheres. Run a clean roller evenly over the paper to produce a clear print of the original drawing made on the inked plate (108:1). You can use the back of a large wooden spoon instead of the roller, if you wish, to obtain gradations of tone and variations in surface effect. The print is then peeled off the inked plate. Normally the process produces only one good, clear print; hence the name 'monoprint'. Sometimes you can take two or three prints from the one inking, but each one becomes successively fainter. Try various types of paper and different textures; by doing this you extend the possibilities of the process and produce an interesting range of prints.

A variation (108:2) of the monoprint technique is to ink the surface of the plate, as indicated, and then place a piece of paper gently on the inked surface so that it adheres. You can now draw in pencil on the paper, and the pressure of the pencil picks up the ink on the underside of the paper. Fingers, a rubber, even a blunt stick, can be used to exert a soft pressure to produce areas of tone, adding interest and variety. The resultant print should show a combination of dark lines and areas with some partially toned background areas.

109 Monoprint, in full colour. Student work.

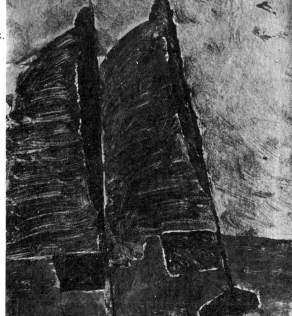

Monoprints also can be taken from paintings in full colour (109) made on the surface of the plate (108:3). Use water-soluble printing inks, preferably, but students' quality oil paint or thick poster paint can be used with absorbent paper if ink is not available. When the painting on the plate is completed, cover it with a sheet of paper, and use either a roller or a spoon to obtain a print. In taking the print, of course, the original painting virtually is destroyed so that only the one print results. This means, in fact, that no two monoprints are ever the same. There is endless fascination in comparing prints and in responding to the variety of effects which you can obtain. Selected monoprints can be mounted, as described previously.

Sandpaper Lithographs

The lithograph technique of the professional artist or printer is a complex process requiring elaborate equipment, but you can use a simple adaptation which requires only the ordinary printing materials, presents few technical difficulties, and offers an additional means of self-expression which permits experiment and individual variation (110).

In addition to the printing materials, you will need several sheets of fine sandpaper, No. 00 or 0 preferably, cut into pieces of convenient size, and soft wax crayons such as marking crayons, or litho crayons. The fine sandpaper becomes a substitute for the limestone slab used by the adult artist. On this sandpaper make a firm crayon drawing in one colour; the crayon must be applied firmly to leave a generous residue on the sandpaper (110:1). As the effectiveness of the print will depend on the arrangement of dark and light masses and

110 Making a sandpaper lithograph. 1—drawing in soft crayon on size 00 sandpaper; 2—inking the crayon drawing. 3—taking a print of the inked drawing.

the contrasts they create, the preparation of a working drawing, as in lino cutting, so that forms and detail can be distributed satisfactorily, is a wise precaution. But you can draw directly with the crayon on the sandpaper, if you desire. Both linear and mass treatments are possible, and you should aim for an agreeable combination of both, exploring fully the ways of applying the crayon to express detail and to introduce textural interest.

When you have completed the crayon drawing, ink a roller, and run it evenly over the surface of the sandpaper so that every line and detail of your crayon takes ink (110:2); the granular surface of the sandpaper, however, takes hardly any ink at all. Now take a print (110:3), using exactly the same procedure outlined for linoleum block printing; the method of printing is identical. You can take a series of prints or lithographs from the same piece of sandpaper if you re-ink it after each print. You will probably find a large spoon the most responsive means of applying pressure.

Experiment freely to discover the possibilities of this technique. Try blending colours on the plate, as described for linoleum block printing; this adds colour interest to the print. Try papers of various qualities and tints with changes of ink to obtain varying effects. Changes in the gauge of the sandpaper also will influence the appearance of the lithographs you make. Mount the most interesting prints you obtain.

Etched or Celluloid Prints

The process of etching, by which an original drawing can be reproduced many times as a print, is a well-known art activity which has a long history dating back to the 16th century. The traditional technique, however, is too laborious and technical for school use, but a simplified version of dry-point etching makes it possible for students to produce quite satisfactory prints (112). The technique, known as celluloid etching, uses printing inks on clear celluloid or plastic plates instead of metal plates, and involves several stages.

In addition to the normal printing materials such as ink, paper, spoons, and glass plates, therefore, you will need pieces of rigid celluloid, perspex, or similar clear plastic, and a range of improvised etching tools, which can be made from discarded dental probes (your local dentist will give you some) or by fitting gramophone needles or large sewing needles into wooden handles.

The four main stages in this simplified etching technique are (a) the preparation of a suitable drawing and its transfer to the plate, (b) the preparation of the paper for printing, (c) the inking of the etched plate, and (d) the printing from the plate. You might consider the cleaning-up process and the mounting of selected prints as additional stages.

First, you should make an outline drawing (111:1) in pen-and-ink or pencil on white paper such as cartridge paper or litho paper; this drawing should be slightly smaller in size than the celluloid plate. Now place your celluloid plate over the drawing, and fix the drawing to the underside of the celluloid with cellulose tape (111:2). As the celluloid is transparent, your prepared drawing can be seen easily. The task now is to reproduce the drawing on the celluloid by incising and scratching the lines with the etching tools you have made (111:3).

111 Making a celluloid etching. 1— preparing the drawing; 2—attaching the drawing to the underside of the celluloid plate; 3—incising a reproduction of the drawing in the celluloid by using a needle; 4—making the dabber; 5—distributing the ink over the plate and in the lines; 6—wiping the plate but leaving the lines inked; 7—the inked plate ready for printing; 8—taking the print on damp paper.

Differences in line are achieved by varying the pressure on the etching tool, and you should be able to obtain lines ranging from thin and fine to heavy and bold. As with linoleum printing, any mark or incision you make on the surface of the plate theoretically should register in the print. When you have satisfactorily etched your drawing on the plate, remove the drawing from the back of the plate, but don't throw it away – it will be needed for reference later.

Now you can prepare your printing paper. Fairly absorbent paper is best; cut it an inch or so larger than the plate on all sides and dampen it thoroughly on both surfaces by dipping in water or by sponging. It is advisable to prepare a number of sheets for printing; pile them together wet-on-wet, and place them between wet newspaper or wet blotting paper so that they remain wet while you ink the plate.

After you have prepared the paper, you are ready to ink the plate. Squeeze a small quantity of printing ink or student quality oil paint (thinned, if necessary, with turpentine), or even black poster paint if nothing better is available, on to your plate glass or masonite, and dab it repeatedly with an improvised dabber – which you can make quite easily by tying cottonwool and several layers of a finely woven material such as cotton around a large cork bottle stopper (111:4), or by inserting a wad of cotton-wool inside a piece of old kid glove or chamois which is then tied tightly at the top. Your inked dabber is used now to distribute a coating of ink over the entire surface of the celluloid plate and in the incised or etched lines (111:5); use partial rotations of the dabber to force the ink into the finer lines. Next, wipe the ink off the surface only, gently using a piece of thin felt or old blanket, folded (111:6); take great care not to remove the ink from the incised lines on the plate. Whether you wipe the background areas completely free of ink depends on the nature of the subject-matter; sometimes you can create a definite mood or atmosphere by leaving the plate partially inked. If you want a clean plate, several final glancing wipes with the heel of your hand should remove the last traces of ink from the surface of the celluloid. At this stage, your drawing, reproduced in ink, becomes clearly visible, and you can check it against your original drawing (111:7).

The plate is now ready for printing, either by spoon (111:8) or in a book press. Spoon printing, again, permits a measure of artistic freedom to vary the pressure, thus adding to the effect of the print. The dampened absorbent paper is placed over the inked plate, and both plate and paper should be placed between thin packing sheets. Firm pressure must be exerted by spoon or by press to force the dampened paper into the incised lines to take up the ink. In all other respects, the printing process is virtually the same as described for lino printing and similar techniques.

The traditional means of printing, of course, is by a special etching press. Presses suitable for use by students are available through art supply stores at reasonable prices. Experience suggests that the best results in term of end-products are obtained on an etching press, but where these are not available alternative means of printing must be explored. Here is an opportunity to show initiative and inventiveness. An effective improvised press can be made by converting a handle-operated clothes wringer, or even an old-fashioned mangle, which can be bolted to a bench or table. If you use a book press, place the dampened paper and the inked plate between pieces of felt or blanket, and insert the lot into the press. By winding the movable jaw down, pressure is exerted so that the dampened paper is forced into the incised

112 Celluloid Etching. Student work.

113 Etching, *'St. Pauls from Watling Street',* (1933) by Malcolm Helsby. In the possession of Max Dimmack.

lines to take up the ink. Leave it under pressure for several seconds, release the pressure, and take out the print. Re-ink the plate, and repeat the process for each print required.

After printing, clean all surfaces and implements thoroughly, especially the plate; if you leave ink in the incised lines to dry hard, the effect of the plate is impaired should you want to take additional prints at a later date.

Again, mount a selection of your most successful etched prints, as indicated on p. 109.

Silk Screen Prints

The idea of fixing a stencil to silk for printing purposes is a relatively recent one, the first patent for a silk screen process apparently being issued in England in 1907. The production of prints of many kinds by the screen printing process is now a well-known technique which is adapted to many purposes, from the production of pictures to fabric printing to commercial publicity and advertising. The process can vary from simple adaptations to complex procedures involving expensive materials, but, to start, perhaps we should only concern ourselves with a simplified approach such as the one which follows (115).

114 Silk-screen print. Student work.

To make your own silk screen prints you will need the following equipment and materials – a lift-up wooden frame hinged to a base (115:2), such as a drawing board or a table top;

fine quality silk, such as Swiss No. 8 Red Line; a specially prepared stencil paper or profilm, either a lacquer base or iron-on base; clear lacquer thinners or an iron, depending on the type of profilm you are using; silk screen colours; one or two stiff rubber squeegees set in wood (8 inch or 10 inch) (115:1); a sharp pointed trimming knife, such as an Exacto or Gillette cutter; and drawing materials with which to prepare your design. All of these materials are readily available from an art supply store, often in specially packaged sets.

Although there are other ways of preparing the stencil, the paper method is perhaps the least complicated and probably the most appropriate for our purposes. The specially prepared stencil paper consists of two thin tough sheets waxed together, face to face, one side of this double sheet being coated with shellac. Using a sharp, pointed cutting tool (115:3)

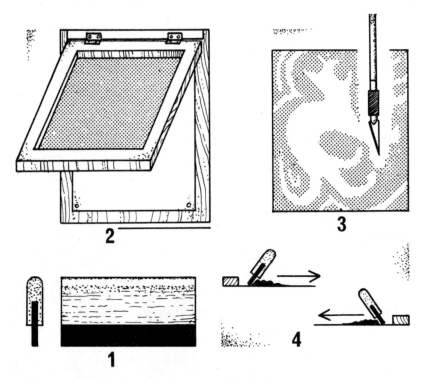

115 Making a silk-screen print. 1—rubber squeegee; 2—the hinged frame showing silk-screen and position of printing paper; 3—cutting the design in the profilm using a sharp pointed knife; 4—method of using the squeegee to force the paint through the silk screen.

you cut your design (which you should have prepared beforehand, of course) into the shellacked sheet, through to the wax layer between the sheets, but leaving the underneath sheet – or the backing sheet as it actually is – uncut. Be very careful during this cutting process for you can easily make an error or damage your stencil. Now lift out the parts of

your design that are to print, using the point of the knife, leaving the background areas fixed in position on the waxed backing sheet. The function of these background areas later will be to prevent the passage of colour through the fine silk mesh. Take your prepared stencil, now, and place it in the correct position for printing. Lower the screen over it, and fix the stencil to the underside of the stretched silk by brushing it with lacquer thinners. An alternative kind of stencil paper requires pressure from a warm iron to fix it to the silk. The waxed backing sheet can now be pulled away quite easily, and after any necessary minor adjustments to the stencil, your screen is ready for a trial print.

Place your printing paper squarely under the silk and lock the screen in position. Now take your silk screen colour and spread a generous quantity on the silk, along the hinged end. While specially prepared colours are available, reasonably satisfactory results can be obtained with other kinds of paint so long as it is thick and tacky; you could try textile paints such as Permaset colours, a mixture of poster paint and starch paste, or powder colour and cornflour paste, or even thick finger paint, if the proper screen colours are not available. If you use Permaset colours you must use the lacquer base profilm.

Use the rubber squeegee to draw the paint evenly and firmly across the screen from one end to the other, so that the paint is forced through all the parts of the silk not protected by the stencil. Hold the squeegee at an angle of about 45 degrees (115:4). This is the most technical stage of the process and it is important that the paint should be of the correct consistency – paint that is too thin will bleed or seep around the edges or penetrate the wrong places, while paint that is too stiff will quickly block the silk mesh. Try to avoid an excessive use of the squeegee; judge the right amount of pressure and work with steady, firm movements. Surplus paint should be scraped up and returned to the hinged end of the screen, ready for the next printing.

After inking, as this stage is called, the screen is lifted and your print can be seen on the printing paper below. You can make any number of prints in the same colour simply by repeating the process. The production of prints in several colours, apart from the problem of colour registration, merely involves more work, for each colour in the print requires a separate stencil and is printed separately in a 'run' or series of printings, so that the print progresses stencil by stencil and colour by colour, the result not being available until the last colour is printed.

When you have finished printing, and the stencil is no longer required, it can be removed from the silk by soaking it with lacquer thinners, and the screen should be cleaned thoroughly. The iron-on type profilm can be removed and the screen cleaned with hot water.

Silkscreen printing as an art experience offers you great possibilities both for a rewarding means of personal expression and also for experimenting with challenging materials and procedures. A number of artists who have specialized in print making have obtained surprising results with the technique. See what you can do. Try various papers. Work up from single one colour prints to more ambitious prints requiring several stencils and superimposed colours. Aim for unusual and interesting effects.

Successful screen prints require mounting and normally are displayed behind glass in the same way as watercolours.

7

Collages

The word 'collage' derives from the French word 'coller' which means to paste or stick. Collages, therefore, are arrangements of different materials of various shapes, textures and colours pasted on backing sheets. These arrangements can be purely decorative and *abstract*, and therefore without meaning, or they may convey meaning either symbolically or in a *representational* way. There are two main types of collage; the flat collage (116), and the raised or 'relief' collage (121).

116 Collage, flat, coloured papers and magazine cuttings, *'Old Soldiers'*, by Janice McBride. In the possession of the artist.

Flat Collages

As the name indicates, these are essentially two-dimensional in nature. (Plate 6).

Materials
To make flat collages you will need textured, coloured materials, natural and manufactured, of a two-dimensional nature and in a wide variety, such as papers of all kinds, magazine illustrations and cut-outs, old photographs, cardboard, fabrics, lace, ribbons, string, threads,

117 Making a flat collage. The tools. 1—scissors; 2—various craft knives; 3—stapling machine; 4—circular punch for making holes in materials.

buttons, matches, and the like. You will need also cutting tools (117) such as sharp scissors and trimming knives; backing sheets of cartridge paper, cover paper, pasteboard, etc., cut to a suitable size; and a wide range of adhesives (118) such as office paste, mucilage, liquid glue, colourless cement in tubes, even milliner's solution, with brushes for pasting. Old newspapers over the working surface to minimize mess and to contain off-cuts save time and effort at the conclusion of the activity.

Technique

The technique essentially is one of selecting, cutting or tearing, arranging and pasting (116), and it offers little technical difficulty. The real difficulty lies in the critical thinking and judgement that must be exercised to evolve a pleasing arrangement, and you will have to consider both an ordered distribution of the various materials and an agreeable combination of colours and textures. Don't start pasting too soon. To produce a successful collage, you should give yourself time to select, to experiment with placements, to consider, to reject, to change, and to re-form. Each piece of material or shape that you add complicates and changes the relationship of all the pieces already in position, and, indeed, of the emerging arrangement itself. In addition, each shape that you use forms a relationship with the background, so that a set of background shapes emerges; these negative or background shapes become as important – and require as much consideration – as the positive shapes you paste in. It is easy to achieve a cluttered effect. It is much harder to know or to sense when to stop. But when finally you are satisfied with your arrangement, then you can commence pasting. Where overlapping of materials occurs, always paste the underneath piece first.

118 Making a flat collage. The adhesives.

Office-type pastes stick most varieties of paper, but you will need mucilage or liquid glue for cardboards, fabrics and heavier materials. Liquid glue and colourless cement will be required for hard materials such as beads, buttons, small sticks, and the like. Materials such as knitting wool, pieces of string, and ribbon often can be stapled (you will find a long-arm stapler most useful for this purpose), but stapling should be kept to a minimum for the making of a collage is essentially a pasting activity. Your cutting tools should be sharp so that all kinds of fabrics, papers and cardboards can be cut easily and cleanly.

Useful Exercises
If you like you can work through a progression of collage experiences, either abstract or representational, commencing with the restricted black-and-white of newspaper through a varied range of coloured papers to collected and scrap materials. If you want to make a representational collage with meaning and subject-matter, you would be wise to select a theme or title beforehand to give direction and purpose to the activity; then you can select materials, shapes, colours and textures and arrange these so that they express the idea or meaning behind your theme.

Say you are going to commence with a newspaper collage. Areas of print, sections of pictorial advertisements or even classified advertisements, portions of illustrations, and even headlines, can be cut or torn, overlapped and arranged on a backing sheet to interpret a theme or form a statement in black and white, and then pasted down. Use your imagination and select newspaper pieces in terms of your subject-matter; tall city buildings, for instance, might be represented convincingly by columns of lottery results lists or by sections cut from the classified advertisements pages. When your pasted arrangement is quite dry, add accents and defining touches with soft black crayon or oil pastel to complete a pictorial statement both creative and individual.

Next, in contrast to the limitations of black-and-white only, you might make a collage in coloured papers (119), using papers of all types, textures, thicknesses and colours – purchased (such as cover paper, poster paper, flint paper, foil paper, surface squares, tinted newsprint, surface board, pasteboard, and cellophane) and collected (such as sweets wrappings, commercial wrappings and packaging, wallpaper, etc.). Again, work experimentally, and thoughtfully, arranging the most appropriate pieces, and colours and textures, to make a well-designed, balanced composition, either abstract or representational.

119 Collage, flat, newspaper and coloured paper. Student work.

Now, as a further variation of the basic technique, combine these two exercises by incorporating both black-and-white and colour. Use cut-outs from magazines and periodicals, especially those published on a weekly basis. This collage should be composed entirely of pieces and areas cut from coloured covers, illustrations and advertisements, as well as from areas of type, so that the problem now is to combine artistically both the black-and-white and coloured elements. When these pasted pictures are representational in intention and appearance, with the separate cut-outs and pieces fitting together to present a composed and coherent pictorial arrangement interpreting a theme or topic, they are frequently called magazine 'montage' pictures.

120 Collage, flat, assorted materials, *'The Engine'*. Student work.

Finally, collages can be made using not only all the kinds of paper indicated, but all sorts of collected and scrap materials, both in a natural form or manufactured (120). So long as the material can be stuck down and is of a two-dimensional nature, the range virtually is unlimited. This extension of the range of materials naturally increases the range of tools and adhesives that you will need, but the technique is still one of selecting, arranging and pasting. Because you now have a wide variety of materials that you can use, you should consider carefully their nature and surface characteristics and again select them in terms of the subject-matter or theme. Colour, texture, shape and general appearance should be considered. Thus, in making a scrap material collage with a theme concerning Winter, the dull winter sky might be represented by a piece of coarse grey fabric, fleeting white clouds by cotton wool, bare trees by dry twigs, a fence by corrugated cardboard, and puddles of water by silver paper or aluminium foil. In this way, the activity becomes both creative and expressive, and a more convincing and interesting personal statement results.

The Raised or Relief Collage

All the collages described so far have been predominantly flat and essentially two-dimensional. Another kind of collage, more difficult and challenging, is the raised or 'relief' collage in which the materials stand out from the background (121). Generally this type of collage involves considerably more serious artistic effort, and the problems of selection, arrangement,

121 Collage, relief, made from polystyrene foam cosmetic packs, arranged, and painted in flat plastic paint,*'Pannonica',* by Graeme Moore. In the possession of the artist.

and fixing become more complex. Frequently they make use of larger materials, such as blocks of timber, pieces of board, strips of metal, creased and folded hessian, plastic moulds, discarded hardware fittings, bathroom tiles, and the like, and for this reason they usually are larger in area and appearance, and require a rigid backing of masonite or plywood. And, naturally, additional cutting tools and stronger adhesives become necessary, especially the PVA-based adhesives. If your relief collage is an artistic success, use it as a wall decoration — in the art room, in your school entrance foyer, or even at home.

Don't think the making of collages is necessarily an activity for children. Most art activities are capable of serious study and application at any age level. Many of the most famous artists of modern times have made good use of the collage technique. And although collages are a comparatively recent art form, they are widely accepted as a legitimate art activity and means of self-expression.

Additional Activity

There is an additional activity involving flat collages that you could try, providing you have had some experience with hand printing and the use of inked rollers. Such collages that have served their purpose, abstract or representational, can be inked by running an inked roller over the surface in all directions so that all the raised areas and prominent textures take ink. When a print is taken of this inked arrangement, delightfully varied and quite fascinating textural effects of considerable aesthetic interest are obtained. The result is called a Collage Print. But, remember, the original collage will be ruined by the inking, so don't use collages that you wish to keep, or display.

8

Modelling

The Nature of Three-Dimensional Expression

In the previous chapters all the techniques and activities we have discussed have been two-dimensional in nature, that is, their end-products -- drawings, paintings, prints of one kind or another -- have all been made on flat surfaces. But with these last three chapters we move on to activities involving the creation of three-dimensional, self-supporting, free-standing forms -- in other words, what we commonly call sculpture. Sculpture, simply stated, is the creating and combining of forms and spaces (122, 123). While different kinds of production produce different end-products, sculpture basically can be *modelled* in a plastic material, *carved* in a solid material, or *constructed* in diverse materials. Chapters 8, 9, and 10, therefore, will be concerned with these three fields of production. While revealing quite natural differences, these three forms of sculpture nevertheless have a great deal in common, as you will discover.

Compared with two-dimensional forms of expression, activities in sculpture involve different kinds of thinking, a changed manner of seeing, and certainly different skills, procedures and materials. Instead of thinking and visualizing in terms of areas, colours, and pictorial equivalents, you now have to start thinking and visualizing in terms of mass, volume, and space, of sculptural equivalents rather than two-dimensional equivalents. In all the forms of sculpture you try, you will find the two most important considerations undoubtedly will be *mass* and *space* -- a mass of material with volume or bulk like clay or plaster or wood or stone, and the space both around this mass and also within it, including hollows and holes, which can be controlled and shaped (151). Inevitably this mass of material takes on a shape, and the *outside* shape, viewed from all sides, always remains the most compelling aspect of a piece of sculpture; indeed, this outside shape should be carefully considered and fully blocked-in before you use hollow forms and holes. If, for the moment, we ignore the nature of the material you are using, then mass and space become the fundamental design elements which you manipulate in making your sculpture, and all good sculpture depends primarily on the sensitive control of these elements. It is true to say, in fact, that an ordered application of mass and space is equally as important as the actual material used. Mass and space, properly manipulated, become contributing, integral parts of the work, as you can see clearly in the solid sculpture of Henry Moore (122) or the open mobiles of Alexander Calder (123).

122 Bronze, *'Draped reclining figure'*, (1957)by Henry Moore (b.1898), showing manipulation of mass and space in a solid form.

123 Mobile by Alexander Calder (b.1898) showing manipulation of mass and space in an open form.

Mass and space, then, are of *primary* importance – indeed, you could produce good sculpture if you concentrated on these two elements alone. But other elements and consider- ations, of secondary importance, become involved, and most of these follow from or become details of your manipulation of mass and space in the selected material, or materials. Never- theless, you should be aware of the meaning and artistic significance of these minor elements, for the way they are exploited in themselves and associated with the material used largely determines the appearance of the created form. Used sensitively, these minor sculptural elements may reinforce and enhance the nature of the created form; used excessively and without feeling, they are certain to impair or even destroy it.

Planes (159) are regular flat or curved surfaces involving length and width but without apparent bulk – like a flat surface on a lump of stone, or a sheet of thin plywood or a piece of glass. *Lines* are relative; they may actually exist or they may be imagined. Lines that exist can be introduced by the materials used, as by wires and rods in a mobile (123), or they can be incised, as in wood carving (150), or they can be applied or added, as in a clay model. Lines can be suggested, and therefore imagined, by the changing boundaries or edges of forms, as in stone sculpture (139), or by the intersection and meeting of planes, as in a constructed sculpture (153). *Textures* are the surface qualities of the materials (129), whether natural as the result of the process employed, as in clay or wax modelling, or deliberately created by incising, scratching, chipping, polishing, and the like. *Light* reveals, defines, enhances, and adds drama to forms created, both by its intensity and the way it strikes these forms (127) and also by the way it is reflected from them. Light as an element is important to the proper display and viewing on any kind of sculpture, and especially so when it is being photographed. Without light there could be no dramatic shades and shadows, no colour. Indeed, without light there could be no apprehension of the forms at all. *Colour* may originate in the surface of the material used, as in polished wood (Plates 7, 8) or stone, or it can be introduced by painting or some other form of pigmentation, or by chemical reaction, but in any case it is a variable element because it is dependent on the nature of the light in which the form is seen.

All sculpture, then, to be good should show a sensitive and disciplined manipulation of mass and space allied to an appropriate use of the minor design elements and an honest use of the physical materials. Without this combination no successful three-dimensional ex- pression in any medium is possible.

The activities indicated in this chapter and the final two will give you experience in considering and applying these elements in a number of forms of three-dimensional ex- pression. It is important to the balance and breadth of your development in art that you have this kind of experience. If you can't get these experiences at school, then obtain the necessary materials and try the activities at home. You should find them challenging, stimulating and truly creative – in many, you will be experiencing some of the oldest arts of mankind, and some of the most fascinating and personally rewarding. But, above all, these activities should prove valuable educationally in the sense that, while learning a great deal about the nature of art itself, at the same time you are developing and exercising continually those basic concepts, attitudes and abilities without which no sound technique is possible.

This chapter will be concerned with one of the three main fields of sculptural activity, modelling. At the very outset, one fundamental, distinguishing characteristic of modelling must be pointed out. Regardless of the material, modelling is an *additive* technique; the form is built up and fashioned from either a mass or pieces of a pliable material. Carving, as we shall see, is subtractive in that the final form is produced by cutting away and reducing the original mass. It is important that you remember this distinction when you are working on the activities described in the following pages.

We shall discuss first modelling in plastic media such as clay and plasticine, then modelling in a pulped or sodden medium known as papier mache, and finally more complex techniques involving modelling materials such as plaster and wax.

Clay

Clay, one of the most common, most useful and cheapest materials known to man, when subjected to a simple cleaning and milling process becomes an excellent modelling material. For a number of reasons, as we shall see, it probably is the best. When it is wet, clay becomes plastic. In this condition it can be squeezed, pulled, pinched, pressed, rolled, cut, joined, and pushed into almost any desired shape. It can be added to or cut and scraped away while the work is in progress. When it is dry it is hard and brittle, and after firing in a kiln it becomes a changed material, durable, impervious and permanent. On the other hand, clay can be mixed with water until it becomes a liquid which can be poured into moulds. And there are many kinds of clay ranging from white to warm brown in colour – each kind has its own appearance, texture, and working properties.

Sources of Supply

In general, clay for modelling can be obtained in three ways. Prepared clay ready for use usually can be purchased cheaply from potteries, brick kilns, and art supply stores. Clay in powder form can be purchased from mineral earth millers or from art supply stores, and is prepared by mixing the powder with water, as follows. Place a quantity of powder in a large dish or bucket and add water (124:3). Allow some hours for the powder to absorb the maximum quantity of water. Drain off the excess water (124:4), and by evaporation allow the mixture to dry to a firm consistency (124:5). The firm clay can then be removed from the bucket (124:6), and stored (124:7). When smaller quantities are required, a simpler method is to spread sufficient powder on a large board, add water, and mix it like dough until the right consistency is attained. But if you live in the country where purchased clay supplies perhaps are not readily available, you can prepare quite satisfactory modelling clay from local deposits. Local clay, the cleanest you can find, should be crushed by pounding and hammering (124:1), and then emptied onto a large flat surface such as a sheet of plywood or masonite so that you can remove foreign matter such as pebbles or grass roots. Reduce your cleaned, crushed clay to a fine powder by rolling it with an old wooden rolling pin (124:2) or some other improvised roller. Collect the powdered clay, then prepare it for

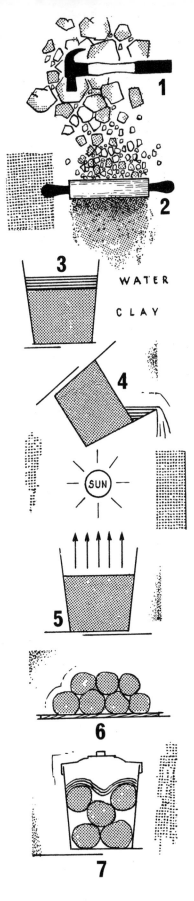

WATER

CLAY

SUN

124 Preparing local clay. 1—breaking up the lumps of clay; 2—reducing the lumps to powder; 3—mixing the powdered clay and water; 4—tipping off the surplus water; 5—drying out the liquid clay; 6—the firmed clay rolled into balls; 7—the balls of clay stored.

modelling as indicated already (124). An alternative method of preparing local clay is to soak it in water until it is reduced to a soft mud; then strain it through fly-wire netting to remove all foreign matter, and allow it to dry out to a firm consistency.

Storage

Plastic buckets or garbage cans (125:1) make excellent storage bins provided you keep the clay covered with a damp cloth or piece of hessian while you are not using it. Smaller quantities can be stored in plastic boxes (125:2) or plastic bags (125:3) kept airtight by rubber bands.

125 Storage of clay. 1—plastic or galvanised garbage can; 2—plastic lunch box; 3—airtight plastic bag; 4,5—packing the balls of clay to permit free circulation of moist air.

Equipment

The equipment you will need for clay modelling is simple and inexpensive – plenty of old newspapers over the working area if you are working in a room; modelling boards of plywood, masonite, laminex or linoleum off-cuts, vinyl floor tiles, etc.; a range of double-ended boxwood (126:1) and wire-ended modelling tools (126:2) which you can buy at art stores; several clay-cutters (126:3) made from thin wire attached to small handles; access to water, and a wet sponge of your own is useful; a collection, in a tin or jar, of odds-and-ends and additional tools for special surface treatments and textures, such as large nails, small files pieces of comb, old toothbrushes, etc.; – and, in addition, nimble hands and fingers; plenty of imagination; and a willingness to try, to see what you can do. So, really, you don't need to buy much equipment at all – you already possess most of what you need. All you have to do is use it!

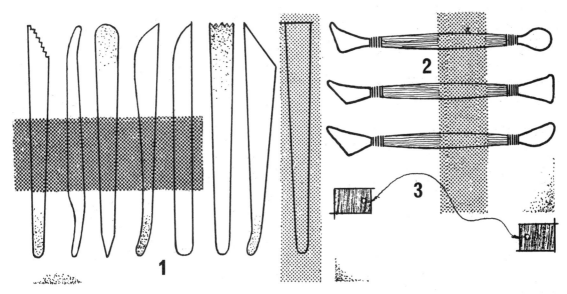

126 Tools for clay modelling. 1—double-ended boxwood modelling tools; 2—wire-ended modelling tools; 3—clay cutter.

Technique

By nature clay is a heavy plastic material which must always be adequately supported, and this imposes certain limitations on its use. Forms in clay must be designed accordingly. Therefore you should work in blocky, three-dimensional forms (127) which are structurally strong, generally with their greatest weight and dimension near the base. Disregard natural proportions, and distort and design your forms to achieve structural strength – make legs thick and solid, for instance, to support the weight of the body above (128), and keep undercutting to a minimum to prevent the collapse of the main mass. Turn your modelling board around constantly as you work so that you consider your model from all viewpoints and so that it develops simultaneously on all sides (129); never work from a single, fixed, viewpoint.

It is sound practice to start with a single, free-standing form modelled from the one lump of clay. Shape your model in this lump by squeezing, pulling, pressing, adding on and building up. Small pieces can be added to build up or strengthen a certain shape. When pieces of clay are added one to the other, make the joins or welds strong by pressing them firmly together. Then smooth over the join with a finger or modelling tool. Excess clay can be removed at any time and alterations made. Use your wet sponge to keep your clay moist while you are using it. You will find that it responds easily to your fingers and you can work on it and reshape it until you are satisfied with the form you have modelled. Surface details can be incorporated by adding pieces of clay, or you can incise them (129), or you can press them into the surface with your improvised tools.

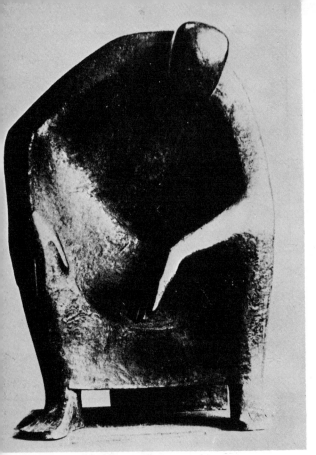

127 Bronze, *'Stooping Woman'*, (1960) by Joachim Berthold (b 1915), showing solid, structurally strong, .simplified mass or form.

128 Bronze, *'Horse'*, (1957) by Georges Braque.

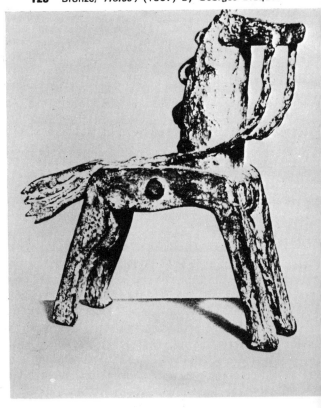

129 Bronze, *'Feminine Head,'* (1951) by Emilio
Greco (b. 1913).

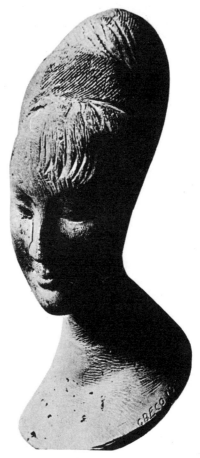

127, 128, 129, While the three works shown
here have been cast in bronze, they were each
modelled in a plastic material such as clay or
plaster before being cast in the more permanent
material.

Your clay model, to be a good one, should be simple in form, strong in construction,
rhythmic in line and shape, and expressive of volume – attributes which reflect the very
nature and properties of the material itself.

Useful Exercises

If you have never modelled in clay or plasticine, here is a program to get you started.

Exploratory exercises

As with any new art medium, commence with short exercises in exploration and familiar-
ization. Get to know the feel and the handling qualities of the material. Experience its weight,
its plasticity, its responsiveness. Try the full range of manipulations like squeezing, pulling,
pressing, and so on. Discover what versatile modelling tools your fingers are. Enjoy the
pleasant feeling of controlling and shaping a pliable material.

Exercises involving the possibilities and limitations of clay

Then devise short exercises to discover the possibilities and limitations of the medium. Model the tallest form that you can. What happened to it? Why? What do you learn from this experience? Now make a large form and set it on a small, thin form. What happened? What limitation does this demonstrate? Try similar exercises. Remember the things you learn from them.

Exercises in definition

To develop your hands as sensitive modelling tools, try simple exercises in definition of form. Using your hands only, model quickly but accurately geometric forms such as a cube, a cylinder, a pyramid, a cone, or a sphere. Aim for uniform flat planes, regular smooth surfaces, straight edges, precise angles – aim, in fact, for perfect forms. You will find that you commence with a rather rough and vigorous hand action, but very soon you will require a sensitive and gentle use of your fingers to achieve the degree of definition and finish required.

Exercises in characterization

Follow these studies with exercises in characterization of form. Again, using hands only, but with active imagination and immediate visualization, model rapid, free, expressive characterizations of familiar animals such as an elephant, hippopotamus, polar bear or a bull. Set time limits on these characterizations – say, a maximum time of 5 minutes – so that they have to be quick, freely modelled impressions. Make your fingers work! Try more of these rapid 'sketches', using human forms such as an old man, a fat butcher, a cowboy, a nun. Aim for the most expressive characterizations possible within the time limit.

Exercises in composition and structure

Try an exercise in composition and structure, which will form a useful introduction to abstract three-dimensional design. Model as perfectly as you can either a cube, a cylinder, or a sphere. Then with a knife or a wire, cut this form twice only, but in any way that you like, so that three pieces result. Consider the nature and shape of these three abstract pieces. Then assemble and arrange them to make a structured, balanced composition or organization that is pleasing to look at. Make a free drawing of your arrangement, to bring out its essential structure and principle of composition. Try several such exercises, for they involve a special kind of thinking and important kinds of judgements and decisions have to be made.

Exercises in grouping forms

Now apply what you have learned from these abstract exercises to an exercise in grouping forms using recognizable subject-matter. Model expressive characterizations involving two or three forms, using themes such as 'Two Friends', or 'Three Sailors'. Make up your own themes. But right from the outset think of your forms as a related, composed and structured group; visualize it in this way and model it in this way. Don't think of it as separate forms which you can fit together when each has been modelled. The purpose of this exercise is to make you think about integrating masses, volumes and spaces to achieve maximum cohesion, unity, and strength.

If you have performed successfully in preliminary modelling exercises such as these, then you should have acquired certain skills and attitudes which will enable you to use your modelling materials as truly expressive media in which to create your own interpretations and characterizations. Devise your own themes for three-dimensional expression. How would you creatively interpret in clay or plasticine themes such as 'Jazz', 'Pop-Singers', 'Sorrow', 'Work', 'Crucifixion', or 'Mother and Child'? To express such themes you must create your own sculptural symbols, shape your material into masses and volumes, invent appropriate surface details and textures, and plan your own arrangement of forms. And if you can do all this, then you are modelling capably. However, quick sketching in clay and plasticine is a supplementary activity that you should engage in continually for the important basic skills that it exercises — imagination, quick visualization, rapid working methods, broad effects.

When you have finished working with your clay, it should be rolled into balls of convenient size, moistened, and stored. Pack the balls of clay in the bin so that damp air can circulate around them (125:4, 5), and so that the clay does not compact into a solid mass. Models which you want to keep — if you haven't access to a kiln — can be allowed to dry hard. They can then be left in their natural finish or you can paint them with poster or similar paints, which dry matt, or with household enamelized paints, which give them a gloss finish. If you model soundly-structured simple forms they should last indefinitely so long as they are not subjected to harsh treatment or dampness.

Plasticine

Good quality plasticine (130), as sold in 1-lb packets by art supply stores, is an adaptable modelling medium for students. It is a finely-ground material that will not set hard or dry out and, therefore, it does not shrink, crack or crumble, as clay does. It is clean to handle and does not stick or stain. Its great pliability ensures that it is always ready for use, and it can be used again and again. Because it does not need continual attention like clay (which

130 Plasticine

needs frequent moistening, for example) and can therefore be worked without interruption, plasticine is an excellent medium for the experimental and expressive exercises indicated in the previous paragraphs on clay; it allows a very free working approach, and its soft responsive consistency permits the modelling of fine detail and also a considerable manipulation of the surface for textural effects and general interest.

You will find, however, that plasticine possesses one characteristic disadvantage; it softens under the influence of heat. Warm hands and constant handling can cause it to become excessively pliable and somewhat difficult to manage. You can largely control this by the use of a modelling tool and a minimum use of your hands. To avoid accidental damage to the emerging model, it is best to work with your plasticine firmly bedded on a square of plate glass, smooth masonite, laminex, or similar smooth, rigid surface.

Plasticine in its traditional form has a wax base and comes in a limited colour range. A recent development has been the introduction of oil-based plasticine in a wider colour range though, as yet, this is not commonly available.

As the general approach to modelling in plasticine is very similar to modelling in clay, details already given of technique, procedure, and exercises, apply equally well to both media.

Other Plastic Media

In addition to clay and plasticine, there are also available other plastic modelling media marketed under various trade names. Most of these are plaster-based, with the setting rate retarded to permit an adequate working time, but they dry out hard and solid. A disadvantage of such media, therefore, is that you cannot use them over and over again, as you can clay and plasticine.

Papier Mache

A less responsive medium than either clay or plasticine, papier mache uses cheap paper such as newspaper soaked in a paste so that it becomes pliable and can then be modelled (131:1).

You will need a cold-water paste such as flour-paste, wall-paper adhesive, or cellulose water-paste, thinly mixed in a bowl or basin. There are two main approaches.

The crumpled paper method
This is the simpler method (131:2), in which sheets or pieces of newspaper are crumpled, soaked in the paste, and squeezed and pressed into a suitable basic form. More paste-soaked paper pieces are then added, and you can keep on adding and modelling by hand until the desired representation is achieved. As the model takes shape, you will need small pieces of torn paper rather than crumpled paper to achieve definition and subtlety of contour. A more pleasing appearance is obtained by using paper towelling or toilet crepe for the final layers. Leave the wet model to dry, and a sunny, windy location hastens the drying rate.

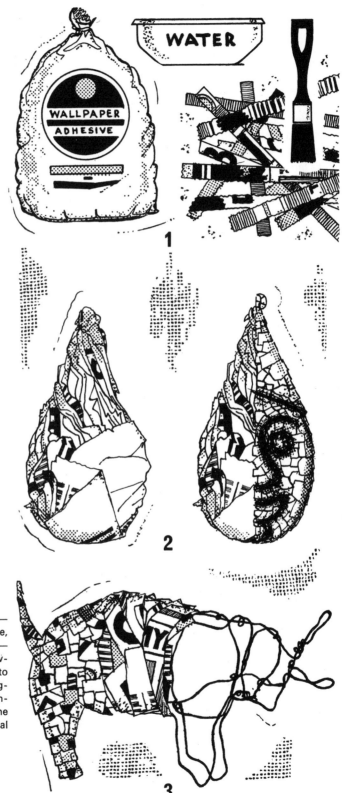

131 Papier mache modelling. 1—the materials; cold-water paste, water, newspaper strips, brush; 2—the crumpled paper method, showing (left) wet paper pressed into basic form, and (right) the emerging model; 3—the wire frame method, showing the building up of the form in paper strips over an internal wire support.

WATER

WALLPAPER ADHESIVE

1

2

3

Then you can add additional significant details, such as fur to represent hair on a human form or a rope tail on an animal form, and paint it suitably to complete the representation. The crumpled paper method enables you to model with little technical difficulty single objects such as animals, human forms, human heads especially and puppet or marionette heads. If you want to make heads, model them on pieces of dowelling or cardboard tube standing in glass jars, so that they stand up and are readily accessible from all working angles.

The wire frame method

The other method is the wire frame method (131:3) involving the use of an internal wire support. Build up the main lines and contours of your model in soft wire to form a strong structure over which strips of paste-soaked paper can be applied. Take strips of newspaper about 1-inch wide, dip them in the paste so that they are thoroughly soaked, and drape or wrap them like bandages over the wire frame to form the first rough 'blocking-out' of the model. Instead of dipping, if you like, you can lay your strips flat on a sink or board and apply the paste liberally with a 2-inch brush. Cover the wire frame completely, and for greater cohesion and strength, criss-cross the paper strips as you apply them. Four or five layers are required to build a strong model, and so that you can keep count, distinguish between layers by using different parts of a newspaper – the picture pages, the classified advertisements, the comic strips, and so on. Press and shape the final two or three layers to define contours and to build up raised areas. Use smaller pieces of paper if necessary to achieve the form you want. If you like, use a final layer of paper towelling or toilet crepe, and a coat of thinly-mixed water-putty applied with a brush gives a hard but pleasant texture when dry. When your model has dried out hard, it can be finished as suggested previously for your crumpled paper model.

Needless to say, papier mache models should be free-standing and three-dimensional, and they should be simple in concept and form. They should progress simultaneously on all sides, from crude beginnings to a more careful modelling to the final shaping and definition of the form. In other words, papier mache models should reflect sound sculptural techniques which respect the characteristics of the materials used.

Plaster

Plaster modelling generally requires the making first of a wire frame or 'armature' to serve as an internal support. The model is then built up around this initial wire arrangement. For small models, use patching plaster which comes in convenient 1-lb. packets (132:1), but for larger models you should buy ordinary trade plaster in a suitable quantity.

Try making a solid plaster and wire model (133). First, make a rough representation (132:3) of the main lines and form of your proposed model in soft wire as you did for the papier mache model, but use plenty of wire and don't leave large gaps. Coil the wire round and round your form, if necessary (132:4). Now mix a small quantity of plaster on a masonite (132:2) or glass plate, press it into the wire framework with a knife or small trowel (spatula),

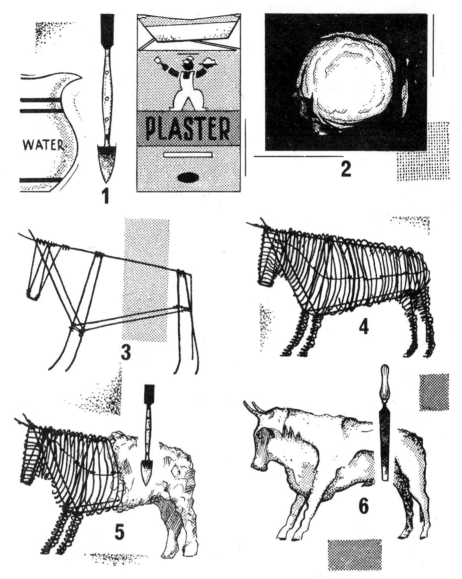

132 Plaster modelling. 1—the materials; water, plaster, spatula; 2—plaster mix on board; 3—basic wire support; 4—basic wire support elaborated into rough representation of proposed form; 5—application of plaster to wire support, using spatula or knife; 6—surface treatment and finish, using rasps, riffler files, etc.

and shape it or smooth it with your fingers and modelling tools (132:5). Mix additional quantities of plaster as you need them. Keep adding plaster until your model assumes the form you want. Allow it to dry thoroughly. The plaster surface can then be filed or sandpapered, scraped with a knife, textured, incised, painted, or finished in any way that you like (132:6). Make sure you clean any files or rasps that you have used with a wire brush or they may eventually rust.

133 Plaster modelling, solid form. Student work.

134 Plaster modelling, open form. Student work.

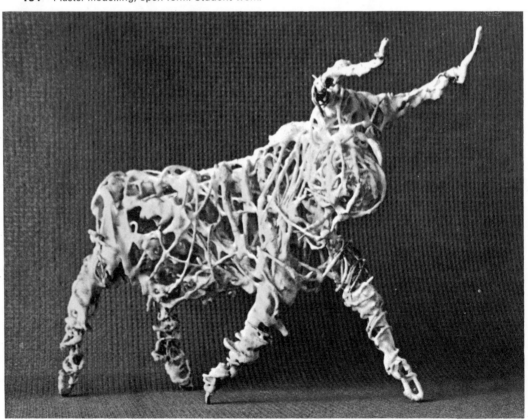

To get away from solid forms – and all our models so far in clay, plasticine, papier mache, and plaster and wire, have involved solid masses and volumes – now try open-form plaster modelling (134) of abstract forms. These will require a different kind of thinking and a changed approach. The element, space, now becomes the main consideration, and you will have to think a great deal about the nature of both the open space around your model and also the space or spaces contained within it. Start by making a non-objective or non-representational arrangement of lines, directions, and spaces in a medium gauge wire, but soft enough for you to manipulate. Don't hesitate to use pliers to shape some of the curves and to achieve tight joins, so that a firm structure results. Now, to produce starkly white, heavily textured forms, coat this wire structure with patching plaster thickly mixed and applied by knife and with your fingers (135:3). Vary the thickness and texture of the plaster to produce an interesting result. Allow it to dry thoroughly, when perhaps some slight refinement of surface here and there with a file or sandpaper might be necessary. You decide!

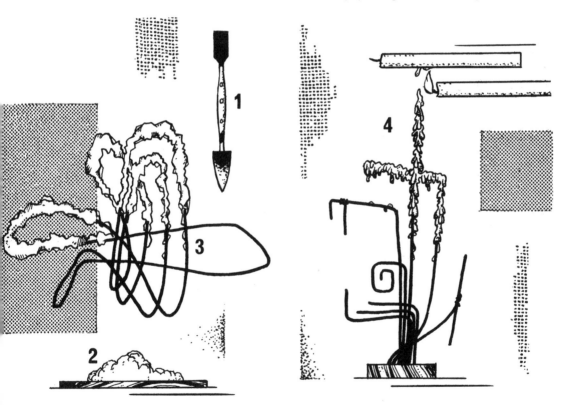

135 Modelling—open forms. 1—spatula; 2—plaster mix; 3—application of plaster to supporting non-objective wire composition or design; 4—application of melted wax to supporting non-objective wire composition.

Additional Activities

If you derived satisfaction from modelling in wire and plaster, you might like to try other modelling techniques using a wire base; they are true modelling experiences because they involve an additive process – you are adding and combining materials.

Again, start by making a design or arrangement in wire. Now hold beeswax, sealing wax, or ordinary candle over a flame (a burning candle, a cigarette lighter, etc.) and let the melted wax dribble and run down the wire construction (135:4). Try melting old wax crayons in the same way, and let the melted crayon introduce odd colour minglings and unusual textures. If you achieve success with these techniques, you might be interested in using liquid solder or a similar material, dribbled over a wire construction to produce an irregular, metallic effect. Dipped, sprayed or painted black with poster or liquid tempera colours, such creations take on something of a wrought-iron look.

The few activities outlined in this chapter on modelling by no means exhaust the possibilities, of course. You can devise further variations or even invent new modelling experiences with the materials indicated. But, above all, experiment. With imagination and initiative, you might even find ways of using other materials in new forms of modelling.

9

Carving

Carving is one of the oldest of the arts, dating, of course, from prehistoric times. Mankind, it seems, has always displayed a strong urge to carve materials for expressive purposes. As an art experience, carving covers a wide range of activities and materials. However, one characteristic is common to all kinds of carving, regardless of material – they are all *subtractive* in that the final form is produced by cutting away a mass (138). And like all sculptural activities, good carving is largely dependent on your developed sensitivity to mass and space and on your proper application of the design elements discussed on page 135. It might be a good plan, at this point, to re-read those pages.

Materials

The main materials which you might consider for carving are – lump clay and unfired bricks; plaster cast in blocks or cylinders; insulating brick, sawdust and cement in block form; plastic products such as polystyrene foam; dry, seasoned woods such as pine, oak, elm, poplar, willow or apple, in the natural state, or dressed timbers such as pine, silky oak, Queensland beech, walnut or mahogany; the harder timbers such as mountain ash, jarrah, or red gum; soft stone such as Mt Gambier limestone, soapstone, soft mudstone, beach sandstone, and similar stones; and cast cement.

Because of the wide range of materials and cutting tools that can be used, you would be wise to select one or two areas of carving experience which you can pursue to some depth rather than to sample a broad range which can only be experienced superficially and with little real understanding. To develop basic carving concepts, attitudes and skills, you should make a simple beginning using manageable materials before you proceed to more ambitious projects.

General Technique

The actual technique of carving or cutting away is basically the same in any material. For this reason, we shall discuss the technique of carving in general terms before we consider carving in specific materials.

First – and very important – you should approach the experience of carving imaginatively and creatively. All through this book emphasis has been placed on the need to see efficiently and to analyse what you see, to penetrate beyond superficial appearances. Use this disciplined or directed vision now to sense or 'to see' a form suggested in your lump of material, whether it is clay or stone or wood (136). Consider the general proportions, dimensions, and

nature of the lump. A lump of stone might suggest the form of a crouched animal, a length of timber an elongated human form. This mental preparation in which the form and details of the subject-matter are visualized is as essential to carving as it is to any other form of creative expression. If such a form, seemingly 'natural' to the material, can be sensed or 'seen' the carving activity can then be directed purposefully towards establishing clearly this hidden form, and to achieving the appropriate surface treatment and detail. Use drawing materials at this stage to make clarifying sketches and working drawings (136, 137). Realize the form first on paper before you start carving. Be clear in your mind what you propose to do. Many sculptors make small models, or maquettes, in clay or plasticine, in addition to working drawings, before they proceed to carve in the selected material. If the nature of the material permits it, some helpful blocking-in of the suggested form in pencil or crayon on the various surfaces of the lump might prove a useful precaution and a subsequent advantage.

As most carving materials are subject to some form of fracturing, splitting or shattering, unwanted portions of material should be carved away in small pieces, flakes, or chips (138,

136 Drawings for sculpture *'Shapes in Bone'*, pencil, by Henry Moore.

137 Drawing for sculpture, *'Seated Figure',* crayon, ink and wash, by Henry Moore.

145). To try to remove large lumps is to risk fracturing the mass. Develop all sides of the emerging carving simultaneously (145, 148), from the initial rough 'blocking-out' (138) of the form to its final detailed definition and finish. Carved forms generally should be simple, and designed and adapted both to fit the lump of material and to respect its properties and limitations (145). Involved forms and intricate detail should be avoided; in most cases, these are rarely necessary or desirable in successful carving. Extended projections, thin unions and excessive undercutting also should be avoided. Realism and natural proportions should not become dominant considerations, and distortions and simplifications should be incorporated in the interest of sound technique and structural strength (138, 139). Use the full size of the lump, both to minimize the amount of carving and also to achieve solidity and strength. Work wherever possible on a solid bench, and work safely at all times – all cutting should be done away from your body, not towards it. Lumps of wood should be secured in a vice, but turned frequently so that all sides progress consistently. Holes through forms can be pierced initially with a drill, and then enlarged and shaped by filing and rasping.

139 Stone carving, *'Madonna and Child'*, by Henry Moore.

138 Stone carving, incomplete, showing the main masses of the emerging form.

At times, recognizable objects might form the subject-matter of carvings in any material; on other occasions forms carved can be non-objective, relying for their effect and visual impact on a controlled application of the design elements already indicated and their agreeable combination with the selected material.

Plaster Carving

Plaster carving (142) is a rather messy activity, yet plaster is a carving medium responsive to a range of cutting tools (140) which includes sharp knives, surform files, rasps of various

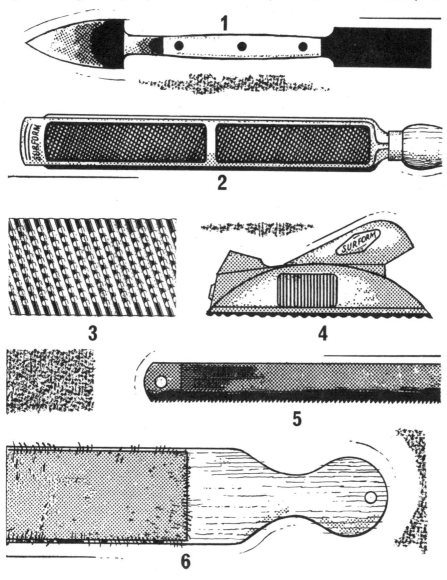

140 Tools for plaster carving. 1—spatula; 2—surform file; 3—detail of surform file to show cutting surface; 4—surform plane; 5—hacksaw blade; 6—wire brush.

sizes, hack-saw blades, and even large nails and similar tools for incising texture and surface details. For work on larger blocks of plaster, additional tools like surform planes, become useful. If you are working in a room rather than a studio or a workshop, cover the working area with newspapers to minimize the mess. Before the actual carving can take place, you will need to cast your plaster block — or better still, while you are going to the trouble of mixing the plaster, you might as well pour several blocks. Large blocks are best poured in wooden frames which you can make to size. If you want cylindrical blocks pour the plaster in cylinders made from old linoleum or celluloid bound with string or wire. Generally, however, blocks of an appropriate size can be poured in boxes such as large chocolate boxes, shoe boxes, and similar open containers, which you can arrange in a row on a news-paper-covered bench or table, ready for pouring. Now mix your plaster. Use good quality

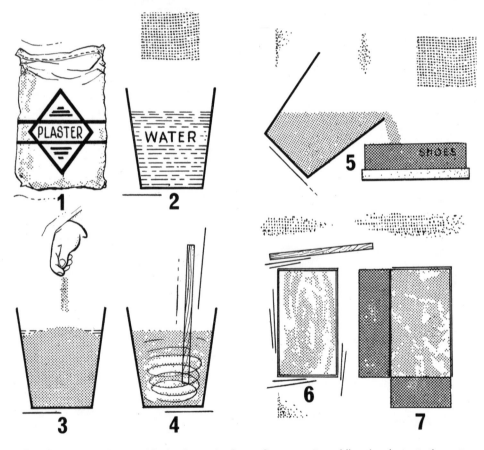

141 Preparation of plaster blocks. 1—trade plaster; 2—water; 3—adding the plaster to the water; 4—mixing the plaster; 5—pouring the plaster mix into boxes or containers; 6—vibrating or tapping to settle the plaster; 7—removing sides of boxes when plaster has set.

trade plaster (141:1) and make sure you add the plaster to the water. Pour a quantity of water into a flexible plastic bucket or basin, say, to half-full (141:2). Then, by the handful, gently run the plaster into the water (141:3), taking care to see that the plaster covers all the bottom of the bucket instead of just piling up in the middle, until it breaks the surface of the water. Stir it thoroughly to break up any lumps (141:4), and you should have a fairly thick plaster mix. Now pour this into your prepared boxes (141:5), and immediately wash the bucket before the plaster sets in it. Gently tap or vibrate each box to settle the plaster, to release air pockets, and to level the surface (141:6). Allow them to stand until the plaster sets – this takes 10 minutes or so, depending on weather conditions and the consistency of the plaster. Then peel away the wet sides of the box containers, and you have your plaster blocks (141:7). Now you can commence carving, in line with the general procedure indicated. One thing you should remember; always clean your tools with a wire brush after carving plaster otherwise they might rust.

142 Plaster carving. Student work.

The sharp whiteness of the plaster imparts a quality to the carving that is both characteristic and attractive; but there can occur times when you might want a coloured plaster. This can be accomplished easily by colouring the water before the plaster is added; powder colours, food dyes, or cement colouring pigment, can be used.

Carving in Other Materials

Carving in other materials – such as lump clay and unfired brick, the soft woods and the hard woods, the various stones and cast cement, which comprise the 'hard' or solid, more resistant materials of carving – depends in general on the same basic carving principles, attitudes, and cutting techniques. In contrast to plaster, however, the nature of these materials changes somewhat, becoming in a number of cases harder to carve and therefore less responsive, requiring better tools in a more extensive range. But the activity of carving remains basically unaltered – only the materials and tools change. A good sculptor, as you know, can work equally successfully in a number of materials.

If you find suitable natural stone such as Mt Gambier limestone (143) difficult to obtain, you can buy an artificial stone sold by art supply stores as a carving material or you can make your own inexpensive and satisfactory artificial stone by mixing sand, cement, and

143 Stone carving, Mt Gambier limestone (incomplete). Student work.

one of the granular insulating materials such as Vermiculite (which you will have to order through a builders supply yard) in the ratio 1 : 1 : 3. Another mixture that you could use to get a different-looking artificial stone is plaster, sand, and insulating material, in the ratio 2 : 1 : 3. Make sure the ingredients you use are thoroughly mixed together before you add the water, then stir them to a thick paste-like mixture. Pour the mixture into coutainers or boxes where it should be allowed to harden; allow three days if you have used cement. If you want to colour your artificial stone, add food dye, liquid tempera colour, indian ink, etc., in the mixing stage.

A range of manufactured products which can be used for carving is becoming more readily available, but some of these might prove too expensive if you have to buy them. Some of these materials, such as polystyrene foam and lightweight insulation bricks obtainable from heating engineers, have a rough or coarse texture which sometimes is not easy to carve and can prove frustrating. These textures, of course, are characteristic of the materials, but they nevertheless constitute a limitation which you must consider and respect in any carving with such materials. Again, design your form to suit the material!

Tools and Equipment

Carving in these harder materials is often a strenuous but absorbing physical activity requiring considerable working time and adequate working space to produce a satisfactory form. The tools for wood carving (144) generally would comprise rasps (assorted shapes, 10 inch and 12 inch), dreadnought files, riffler files, surform files (flat, round, half-round), woodworking gouges (assorted shapes and sizes), firmer chisels (assorted sizes), a sharpening stone, a beechwood mallet, saws, sandpapers, steel wool, and finishing materials such as wood stain, shellac, lacquer, floor polish, shoe polish, etc. The use of 'G' clamps (8 inch and 10 inch) and a bench and vice are often necessary, while a sharp tomahawk is a useful tool for quickly removing larger pieces of rough, exterior material.

The range of stone carving tools (146) would include pitchers (for rough work and to remove larger lumps of unwanted material), points (for working up forms), claw tools (for shaping), flat chisels (thick, for heavy work; light, for finishing surfaces), stone gouges (for use on soft stone), a square-headed iron hammer about 2-lb. weight (or a plumber's mash hammer will do), riffler files (curved at both ends), surform files, rasps, and perhaps abrasive materials such as carborundum stones, emery cloth, etc., for finishing, although these should rarely be necessary.

The tools indicated above are the ones used by experienced or professional sculptors. You need the proper tools if you want to participate in worth-while carving experiences. As a student you should try to obtain at least a basic set. For stone carving, for example, you would need at least a point, a claw tool, a flat chisel, a riffler file, and a hammer; a similar basic set could be devised for wood carving.

Experiment freely first to find out what the tools can do; discover their cutting properties and the special functions they perform. Have a trial run on a piece of suitable material. In

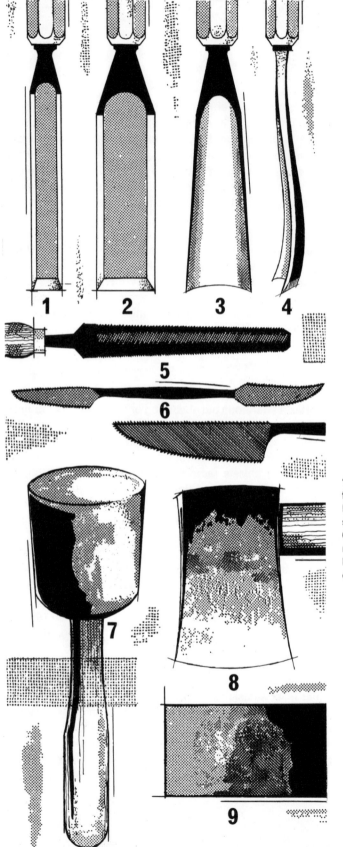

144 Tools for wood carving. 1,2—firmer chisels, small and large; 3—large gouge, straight shank; 4—small gouge, curved shank; 5—rasp, 6—riffler files, small and large; 7—mallet, round-headed or square headed; 8—tomahawk; 9—sharpening stone.

145 The technique of wood carving. 1—preliminary design, appropriate to the material; 2—the design transferred to the material; 3—initial blocking-out of the outside shape of the form, using the larger cutting tools; 4—defining the emerging form, using the smaller cutting tools; 5—surface finishing, using rasps, files, sandpaper, etc. 6—the completed form, respecting and reflecting the characteristics of the material.

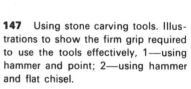

146 Tools for stone carving. 1—pitcher; 2—point; 3—claw tool; 4—flat chisel; 5—square-headed iron hammer.

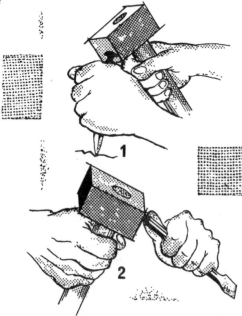

147 Using stone carving tools. Illustrations to show the firm grip required to use the tools effectively, 1—using hammer and point; 2—using hammer and flat chisel.

general, proceed from large tools, firmly held (147), and more vigorous action when re-moving unwanted material to the smaller tools and a more careful and controlled approach to the cutting when shaping and finishing the created form (145, 148). Keep all cutting edges sharp, of course, and all tools clean – don't allow files and rasps, for example, to clog up with compacted waste material. Keep a wire brush handy, and use it!

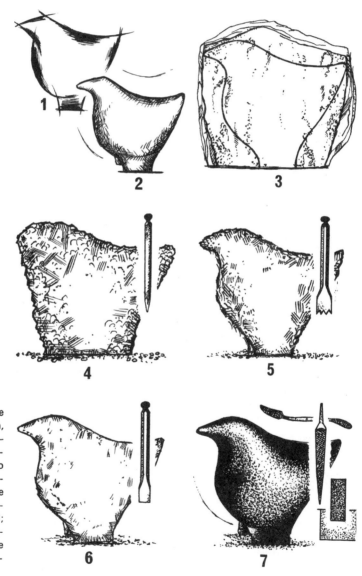

148 The technique of stone carving. 1—preliminary design, appropriate to the material; 2—clay or plasticine model or maqu-ette; 3—the design transferred to the material; 4—initial blocking-out of the outside shape of the form, using the point; 5—shap-ing the form, using the claw tool; 6—further shaping and definit-ion, using flat chisels; 7—surface finishing, using stone files, rif-fler files, etc.

A Recommended Approach

In any sort of carving, a developed sensitivity towards the material and an understanding of its properties become essential. For instance, you can't carve successfully in wood, really, until you understand something of wood as a material — what you can do with it, what you can't do with it. In other words, you have to develop a regard for wood *as wood*. So start off in a creative, experimental, exploratory way — by trial-and-error, if you like — to learn as much as you can about your carving materials and how they respond to the cutting tools. Commence with small simple forms, and as your skill with the tools develops, then you can become more ambitious. In wood carving, for example, after you have had a number of exploratory, introductory experiences with the various tools — trial 'runs', if you like — try carving *a simple, non-objective 'hand' or 'touch' form* (149) which a certain piece of wood

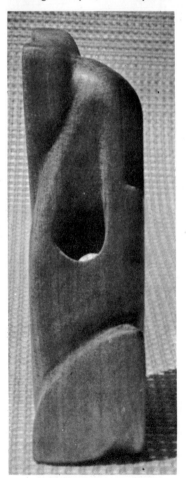

149 Wood carving, touch form.
Student work.

might suggest – a form that is just an eye-pleasing arrangement of concave and convex surfaces with or without holes, to bring out the beauty of the wood, and small enough to be held comfortably in your hand. Make sketches and drawings first so that you have a clear idea of the form to be carved, from all points of view. Keep these drawings close by, for reference. These preliminary drawings exercise your capacity to sense or visualize the form hidden in the material. Try creating several of these abstract 'hand' sculptures, each related to the other so that they show an affinity of form. Try also *simple, free-standing geometric forms*, singly or in combination, handled in a similar way. Then move on to *descriptive forms*

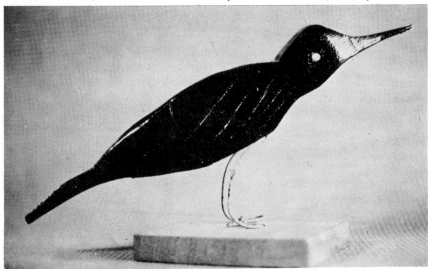

150 Wood carving, simplified bird form. Student work.

in the round (150) – recognizable but simplified forms (human, bird or animal) carved, for instance, from off-cuts and small blocks, relating the shape of the form of the character of the wood, to enhance both. Again, make clarifying sketches and working drawings to give you a clear realization of the form you are carving. Use the appropriate range of cutting tools, and aim for a surface treatment in harmony both with the form carved and the material used. Finally, following such a series of experiences and exercises involving wood carving techniques – exercises which have developed a 'feeling' for wood as a material and provided a working knowledge of the appropriate tools and processes – you are ready for more ambitious projects and the creation of wood sculpture (151) much larger in scale, using your carving skills as the means to a creative form of self-expression. To protect the surface of your sculpture and to bring out the beauty of the form and grain of the wood (Plates 7, 8), the carved form can be treated in several ways, the principal treatments being staining, oiling (with Swedish oil), waxing (with shoe polish or floor polish) light varnishing or shellacking, or the application of heat to scorch the surface, for example, by gas flame or blow-lamp.

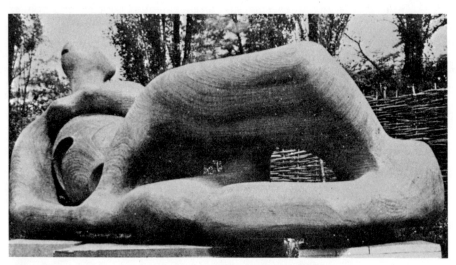

151 Wood carving, *'Reclining Figure'*, (1946) by Henry Moore.

The kind of developmental approach outlined above for wood carving applies equally to stone or to any of the other carving media. Proceed experimentally from simple beginnings. Plan a program of your own suitable for your selected material; devise exercises and activities that show a progressive increase in difficulty and in range of tools, and, perhaps, in scale. In planning your own program of activities, you become personally involved and much more interested in this business of learning to carve and to create original, aesthetically satisfying sculptural forms.

10
Constructions

In general, modelling and carving are concerned with solid masses of material; the techniques used, therefore, are techniques of sculpture in the mass. The creation of free-standing constructions, however, exploits the element of space, so that the techniques used constitute sculpture in *space* (152, 155). We might describe constructions, then, as three-dimensional designs using one or several different materials, and which incorporate and become part of a volume of space. The appearance of the construction results ultimately from the relationship between the lines and shapes of solid and transparent materials and the openings and amount of space that these materials contain and enclose (152). Open areas and

152 Free-standing construction in brass and iron, (1953). by Nicolas Schoffer (b. 1912).

153 Stabile, in black metal, (1959) by Alexander Calder.

154 Enclosed construction, wood (detail), (1961) by Louise Nevelson (b. 1900).

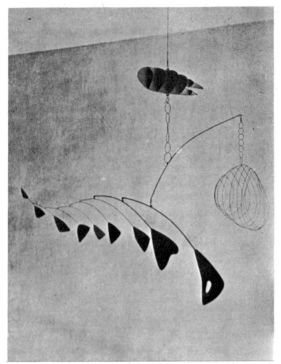

155 Mobile, steel wire and sheet aluminium, *'Lobster Trap and Fish Tail'* by Alexander Calder.

spaces, therefore, become as important to the design as solid forms and masses. Some constructions may emphasize the relationships between solid shapes and enclosed spaces, as in a free-standing wooden construction (159), while in others the emphasis might be on lines and the open shapes and spaces between the lines, as in a mobile (161). In both cases, the manipulation of space is a basic problem. And this interest in space can be further complicated by the use of transparent materials such as sheet plastic or perspex.

To produce a successful construction, therefore, you must have some feeling for – and certainly some understanding of – three-dimensional form and structure. In addition, you will have to consider not only the structural strength of the construction but also the visual appearance of its arrangment if the end-product is to prove a satisfactory design.

Technique

Making different kinds of constructions and working with the almost unlimited range of materials and the wide variety of tools they require will provide continuing opportunities for all kinds of experimentation as you explore the various possibilities, limitations, and difficulties. There are no set techniques or working methods, so you will have to evolve your own according to the needs and problems of your construction, and here again you

are offered unique opportunities for the exercise of inventiveness and adaptability. At times, you will have to modify your ideas or intentions to suit the materials and tools available; on other occasions, you can choose or adapt materials specifically to suit your ideas.

Materials

To exercise fully the special kinds of thinking and abilities needed, and to obtain maximum artistic benefit from the experience of making constructions, it is essential that you have access to a wide variety of interesting, challenging materials. Most of these – in fact, all you need probably – you can easily collect round about you. It might help you to think of materials in perhaps five main groups or categories. *Hard materials* comprise pieces of wood of all kinds; dowelling and mouldings; hardboard, masonite, and similar manufactured wood products; ice-cream sticks, matches, toothpicks; heavy strawboard; laminated products; metal off-cuts, metal tubing; and so on. *Flexible materials* would include wire of all kinds, plain and plastic covered; cane; papers of all kinds; thin card; corrugated card; aluminium foil; thin sheet metal (cut from fruit tins, if necessary); fly-wire screening; and similar materials that you can bend easily. *Pliable materials* are all your soft materials such as string; wool; threads of all kinds; plastic thonging; tapes; raffia; fabrics; and the like. *Transparent materials*, naturally, would include glass; sheet plastic and perspex; polythene sheeting; celluloid; talc; sheet gelatin; and cellophane. *Miscellaneous materials* would comprise an intriguing, quite fascinating collection of odds-and-ends and old gadgets, including discarded items of builders hardware; nuts and bolts and washers of all sizes; coiled springs; old flash-light bulbs; keys; corks; bottletops; and, in fact, almost anything – it will be a challenge to your inventiveness and creative approach to find a use for these odd bits and pieces that you collect. The materials indicated in the full extent of their several categories, comprise the raw materials which, when selected and combined agreeably with all the design elements – but especially that of space – should make your construction an individual, unique and creative outcome of a valuable experience in invention and improvisation.

Tools

The essential tools for making constructions comprise mainly cutting tools (156) and joining materials (157). Thus you will need trimming knives; scissors; side-cutting pliers; a small saw such as a tenon saw or a dovetail saw and a coping saw; a claw hammer and a small Warrington hammer; and a drill, preferably a $\frac{1}{4}$-inch electric hand drill. A paper punch, a leather punch, and serrated dress-makers shears are also useful cutting tools. All cutting, of course, should be done on a cutting board, on a bench or table. Because of the wide variety of materials that the different kinds of constructions might involve, you should have access to a full range of adhesives, from ordinary paper paste, to cellulose tapes, to glues and

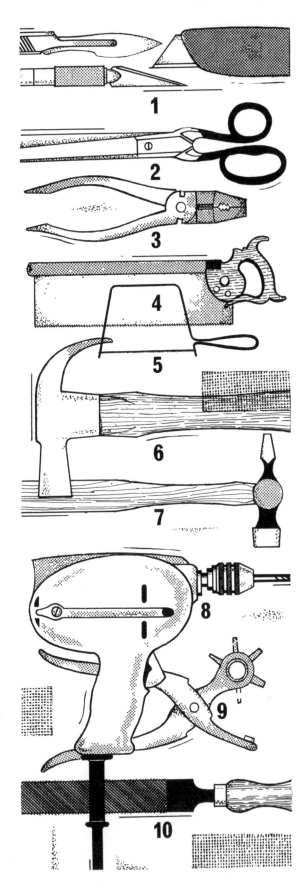

156 Tools for creative constructions. 1—trimming knives; 2—scissors; 3—sidecutting woodwork pliers; 4—dovetail saw; 5—coping saw; 6—claw hammer; 7—Warrington pattern hammer; 8—$\frac{1}{4}$-inch electric drill; 9—circular punch; 10—wood rasp or file.

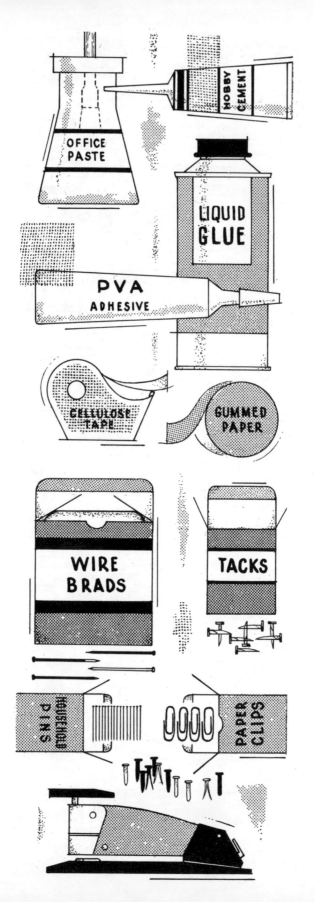

157 Common joining materials for creative constructions.

cements, to the synthetic resin or PVA-based wood-working adhesives, and additional joining media such as tacks, brads, pins, and the like, and a long-armed stapler. Finally, in order to impart colour interest to surfaces and materials, and generally to give a 'finish' to the construction, you will need brushes and paints; water-based paints such as poster or tempera colours will do.

Kinds of Constructions

Many constructions are made by modifying and combining ready-made forms. When the basic or predominant material used is paper, such constructions are called *paper sculpture*. When wire forms the main material in an open construction, the end-product becomes *wire sculpture*. When larger objects, scrap forms and found objects are used, the constructions are often referred to as *junk sculpture*. Constructions such as these can be simply non-objective three-dimensional designs in space, with no significance other than the visual appeal and interest of their materials and the nature of their structure. On the other hand, the artistic intention might be representational, and the appearance of the construction based on recognizable subject-matter.

 Non-objective and abstract constructions which remain fixed or static we call *space sculptures* (152) or stabiles (153), and they may be free-standing (that is, in open or unrestricted space) or enclosed (that is, contained within a restricted space, such as the interior of a box). Constructions which incorporate the element motion and therefore are able to move, either suspended in space or springing into space from a base, are called *mobiles*.

Space Sculptures
The problem of the space sculpture is to achieve a coherent, unified, visually interesting construction of lines (in the form of pieces of dowelling, wire, string, wool, and the like), masses and planes (formed of shapes of plywood, hardboard, card, paper, plastic, cellophane, flywire, or light metal), arranged both to manipulate the space it encloses or contains and to animate the space it occupies. The utilization of space, therefore, becomes a major consideration. The selection and combination of the various materials should be allied to a satisfactory composition or relationship of the parts, and the construction should show a dominant area or focal point – a centre of interest. Free-standing space sculptures or stabiles usually are constructed on a wooden base and project upwards to occupy and animate an unrestricted space. Drill your base block first to accommodate the main uprights of the design which are glued in position in the holes, and from this beginning the construction can develop in any way that you like. It can grow as a static arrangement of intersecting horizontal and vertical lines and planes, or as a dynamic construction of diagonal directions and movements countered and controlled by transverse lines and planes. Whichever way it develops, when the construction is completed as a unified design with an established centre of interest, you can paint selected parts in poster paint to add interest and to enhance its general appearance.

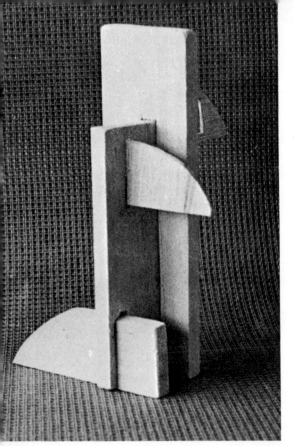

158 Free-standing construction, balsa wood. Student work.

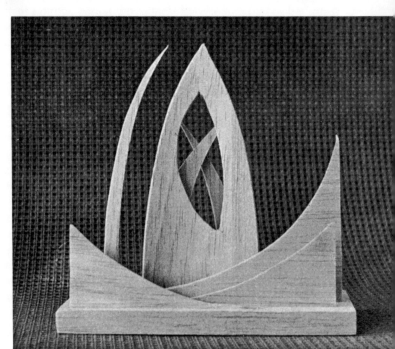

159 Free-standing construction, balsa wood. Student work.

With the enclosed space sculpture (154), however, the procedure is somewhat different, because you must first prepare the inside of the box or carton as a setting for the design. You can do this by pasting in strips, shapes or areas of coloured paper to serve as a background and to make a contribution to the design, or you can paint the interior in poster paints in flat colour areas or geometric shapes, or the paint can be dribbled, splashed, stippled, or applied in any way appropriate to your proposed design. While the box or container is drying, select your linear and plane materials, and paint or otherwise prepare them for assembly. The problem now is to construct a coherent and interesting design in related materials within the enclosed space of the box. Coloured wools, threads, string and thin wire become important materials and you can thread them through holes punched or pierced in the sides of the box, where you can terminate them by stapling or taping, or they can be returned in a different direction or angle. Strips or areas of paper or card can be glued in position. Wooden skewers or lengths of dowel can be fixed in position on drawing pins, tacks, or lills pushed through or tacked from the outside. Many shop window displays, in the aids, materials and modern display techniques they employ, show the principles and nature of space sculpture applied to large scale situations. You can learn much from these displays, especially about contained or enclosed space sculptures. Next time you are in the city, study one of the more spectacular window displays; disregard the subject-matter of the display, but analyse it as a design in space. Discover for yourself the principles underlying its arrangement, and more particularly, how the design elements have been applied and related to the materials of the display.

Mobiles

Mobiles, an art form of modern times, are now widely accepted in adult art. In any art program, they form valuable problem-solving experiences in design and the use of materials. The main problem of the mobile is the management of lines, planes, and materials in motion in space (160), but there are also challenging supplementary problems of balance and construction. An essential requirement to the making of a mobile is a *theme* to interpret, to give the activity a direction. In this way the mobile becomes not only a problem of construction and control of balance and movement but also a form of creative expression (161). However, the forms and shapes need not be realistic; in fact, you will find that the basic theme can be interpreted and expressed better in simplified and abstract shapes that are suggestive rather than representational. You will see this point clearly demonstrated in the designs of the well-known American exponent of the mobile, Alexander Calder (155).

Commencing from a supporting wire hook, the mobile evolves as a rhythmic arrangement in balance and motion. Laterals or arms of linear materials, like wire or dowelling, are introduced to carry pendants or hanging pieces, and each arm and the pendants it carries must be properly balanced. You will find it less troublesome to balance each lateral and its pendants separately before you incorporate them in the evolving mobile. The organization and combination of many suspended forms in balance constitutes one of the main problems which you will have to solve. You can achieve balance by altering the position of the fulcrum, or by introducing heavier or lighter pendants as needed, or by adding small spheres of clay

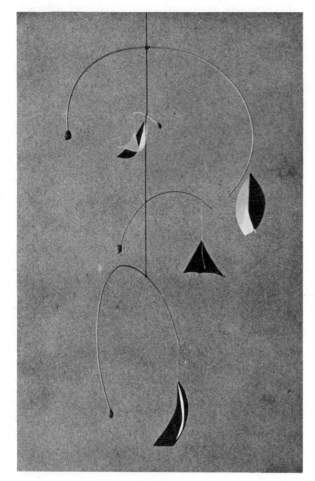

160 Mobile, coloured paper, *'Sails'* theme. Student work.

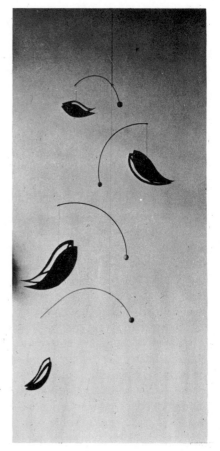

161 Mobile, coloured paper, *'Fish'* theme. Student work.

(or plasticine), varying in size, to the ends of the laterals to serve as weights (161); when they are dry, you can paint them in bright colours so that they contribute to the final appearance of the mobile. You will discover that a very real difference exists between visual balance, which concerns the size of the form, and physical balance, which concerns the weight, and you will have to adapt your construction accordingly to achieve perfect equilibrium. Motion, of course, is an integral part of a mobile, and should be considered simultaneously with construction and balance; the word 'mobile', in fact, suggests movement. You can anchor parts of your design so that they are static; others, freely suspended, are animated and moved by currents and eddies of air so that the construction is in a continual state of movement. Aim for simplicity in both the number of forms and the range of materials, and don't overload the growing mobile with an excessive number of pendants. Finish main joins in wire neatly with a twist of the pliers, and trim the ends of knots in string, wool or cotton. As well as showing sound construction, balance, and controlled movement, your mobile should exhibit a tidy and attractive appearance if it is to be an effective art form and a successful interpretation of its theme. To display finished mobiles for the best effect, suspend them safely in corridors, entrances and foyers, and particularly in rooms, where they become unique decorations and aerial focal points.

As a variation of the suspended mobile, you can construct a mobile so that it springs from a base piece. From a block of wood or similar base allow a long wire arm to project upwards in either a swinging arc, or as a vertical and a lateral in an inverted right-angle formation. Suspend a wire hook from the end of this arrangement, and you can proceed to construct your mobile as indicated.

Junk Sculpture
The use of the found object in the successful construction of junk sculpture depends, to a great extent, on your exercise of *choice*. And the more imaginatively you exercise your choice, the more creative and personal the construction is likely to be. The act of choosing, in fact, itself becomes a creative experience, and the things you choose and the way you use them vitrually become a reflection of you as a person – like choosing your own clothes. All kinds of abandoned, obsolete, broken, unwanted or unused objects can suggest expressive possibilities and artistic uses. Some may need little alteration or treatment; others may entail much work; and many can be combined or arranged in unusual ways for extraordinary effects. All become transformed, so that they lose their original identities and assume, as it were, new personalities (163, 165). The construction of junk sculpture really requires the building-up of a collection of found objects, and the more varied the collection the greater the scope for creative action. Old clocks; parts of vehicles (162) and machinery (163); metal scrap (164), cast-iron plates, and fittings; old containers, pots, and similar vessels; pieces of driftwood; lumps of building materials; old architectural fittings (165) and hardware – these are the items in which you can discover unrealized expressive potential. Start collecting now! The impulse to collect such objects, to choose them above all others, is part of a deep-seated urge that causes people to collect bottle-labels and sea-shells.

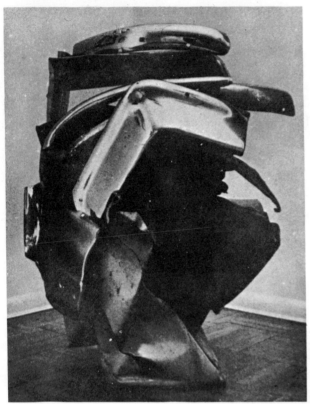

162 Junk sculpture, auto bumper bar pieces, *'Silverheels'* (1963) by John Chamberlain (b. 1927).

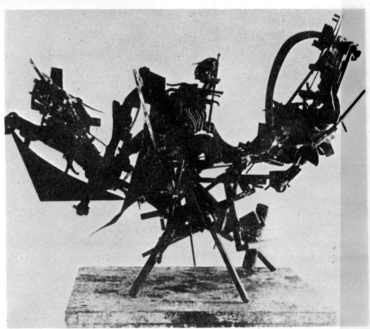

163 Junk sculpture, machine parts, untitled, (1963) by Robert Klippel (b. 1920).

164 Junk sculpture, angle iron steel, untitled, (1961) by Richard Stankiewicz (b. 1922).

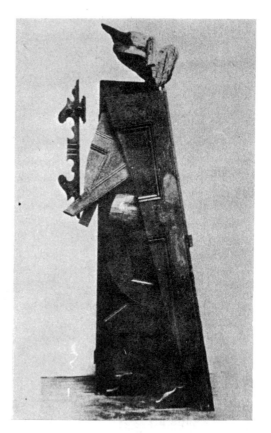

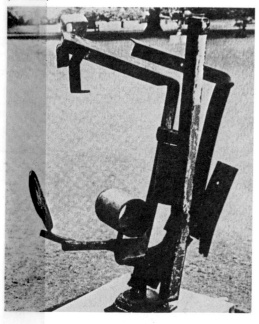

165 Junk sculpture, wooden architectural fittings, *'Woman with Flowers'*, (1960) by George Fullard (b. 1924).

As with the making of other kinds of constructions, no set building techniques or working methods can be recommended. You will have to work out your own as you proceed. It is likely that you might need additional tools of various kinds, more specialized adhesives, and perhaps soldering.

But working with these kinds of materials to produce a visually satisfying, well-designed construction in junk sculpture is an absorbing occupation with exciting rewards — an experience that will open your eyes to the expressive possibilities and, indeed, the unnoticed beauty and interest of the everyday, familiar, abandoned objects all around us.

Conclusion

Quite obviously, the ten chapters of this book do not contain all the art activities you can do, nor do they attempt to mention all the materials you can use. They represent only a selection; there are many, many more available to you once you have become interested and your confidence and skill develop. The activities described, however, do offer a balanced range of two-dimensional and three-dimensional experiences which, when considered in conjunction with the approach advocated, constitute a sound, basic art program.

In conclusion, then, it seems fitting to re-state that art is essentially an *activity*; it involves action. You learn about art by making art. It involves participation in a personal, self-directing way. And the basic aspect of any active participation in art is seeing. Learn to see. Learn to see in a personal way. All the artists in history developed their own unique way of seeing. Giotto saw the world in a way quite different from his contemporaries. So did Masaccio about a hundred years later. So did El Greco, and Rembrandt, and Constable, and Monet, and Cezanne. And so have the great artists of today. So look penetratingly at the world around you. Do your own selecting from the fascinating wealth of subject-matter that surrounds you. Do your own thinking. Make your own decisions. Form your own responses, emotional as well as visual. Devise your own way to translate this personal response into appropriate pictorial or sculptural equivalents. Express yourself in your own way, in the way that seems natural and right for you. And if you do all this – no matter how successful and excellent the end-products, or how poor – you are employing the same processes as the mature, experienced artist.

You are, in fact, functioning as an artist. To help you to function in this way has been the purpose of this book.